Edna's Nudes

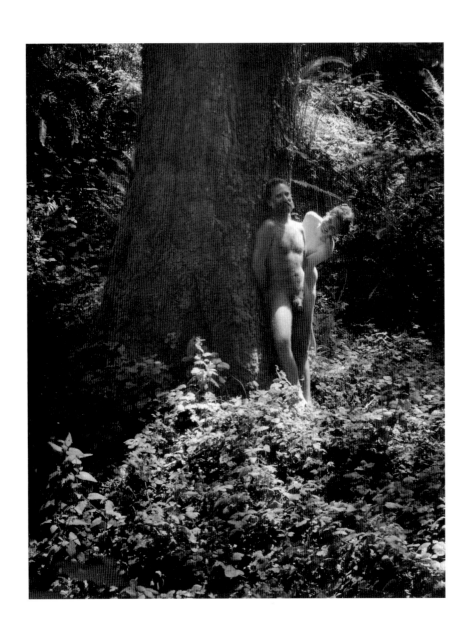

Edna's Nudes

PHOTOGRAPHS BY
Edna Bullock

TEXT WRITTEN AND EDITED BY
Barbara Bullock-Wilson

WITH AN AFTERWORD BY
Karen Sinsheimer

CAPRA PRESS
SANTA BARBARA

Front cover photo: *Three Nudes on Dunes,* 1990

Frontispiece: *Jane and Marc,* 1988

Cover design, book design and typography by Frank Goad, Santa Barbara, California

Black and white photography scanned by Chroma Litho, Santa Barbara, California

Back cover photo of Edna Bullock by Naomi Reddert, 1981

LIBRARY OF CONGRESS CATALOGING-IN-PUBLICATION DATA

Edna's Nudes
photographs by Edna Bullock ; text by Barbara Bullock-Wilson and Karen Sinsheimer
p. cm.
Includes biographical references (p. 103).
ISBN 0-88496-369-1. — ISBN 0-88496-393-4 (pbk.)
1. Photography of the nude. 2. Bullock, Edna. I. Bullock-Wilson, Barbara.
II. Sinsheimer, Karen. III. Title. IV. Title: Nudes.
TR675.B76 1995
779' .21' 092—dc20
94-45672
CIP

CAPRA PRESS
POST OFFICE BOX 2068
SANTA BARBARA, CA 93120

To Wynn with love.
—E. B.

INTRODUCTION

W HO WOULD HAVE THOUGHT our family would have *two* photographers to share with the world? Certainly not my mother Edna whose photography this book celebrates. Occasionally a new acquaintance would ask her, "What about you? Do you photograph as well?" For years, her answer remained emphatically the same—"Goodness no, there's room for only one photographer in this household!"

And that's the way it was as my sisters Mimi and Lynne and I were growing up. Wynn Bullock, whose international reputation was established with his images in the famous *Family of Man* show, was The Photographer. His love for the medium was so intense and his identification with it was so complete in all our minds that there was simply no desire to pursue photography for ourselves.

All this changed when Dad died of cancer in 1975. Within a year of his death, Mom announced she was going to try photography for herself and, although her decision caught the rest of us by surprise, she had no doubts about her choice of direction.

It wasn't as though she had been waiting in the wings for her turn in the spotlight. Becoming a photographer had never been one of her aspirations. But being widowed at sixty, she saw the possibility of many active years stretching ahead of her. She was blooming with health (except for some arthritic joints), had the energy of a kid with the enthusiasm

to match, and very much needed to feel useful and productive.

As Mom thought about what to do with the rest of her life, the process of elimination was easy. Although she had been born with a special love and talent for dance, her body was no longer a willing performer. Given her reputation as a skilled, conscientious, caring teacher, she would have been welcomed back to the local school system, but that possibility held no appeal for her. She had already tried her hand at writing children's books and found that she was much more visual than verbal. Never a joiner, club affiliations had no allure for her, and neither did volunteer work.

On the other hand, what she did feel was an increasing urge to be artistically creative. Throughout her marriage, Mom's inherent creativity had taken many different forms. As a wife, she had been supportive of her husband's needs and interests while managing not to neglect her own. She had been a nurturing and loving mother who had encouraged my sisters and me to be the people we wanted to be rather than extensions or projections of our parents. As a homemaker, she had sewn most of our family's clothes, taught us to appreciate ethnically diverse foods, imaginatively decorated the house and yard for holidays and celebrations, made up wonderful games and presents, and kept the house filled with flower arrangements from her garden.

Wedded to a particularly focused and outspoken photographer who kept company with many other well-known artists, Mom, on occasion, had seen herself as "dull and uncre-ative" in comparison, but the potential damage that image could have produced never found enough ground to take root. In her thirty-two years with Dad, she had mostly emanated a contentment about her life, making home a happy, comfortable place for us all.

With her beloved husband gone and children grown, however, the opportunity for change had suddenly arrived. And with that opportunity came the awareness that becoming more explicitly creative was indeed what she wanted.

Although several paths would have been open to her (for example, she could draw and paint with considerable skill), in her mind there was only one that made sense. She had inherited a well-equipped darkroom, several fine cameras, and a stockpile of supplies. In her marriage, she had witnessed and supported the development of a world-class photographer and, along the way, had evolved her own aesthetic sense of the medium.

Beyond all this, she already had strong ties with the photographic community and a highly recognizable name. These, she reasoned, would be an asset to someone starting out at her age, and since she was basically a secure person, she was not intimidated by her famous husband's reputation or accomplishments. On the contrary, the decision to pursue photography gave her a bridge across death and grief to a new life that still included the presence of the man she had cherished. As she explained to us with a smile and a shrug, the choice was an obvious one and, in 1976, she promptly launched her new career by

enrolling in a beginner's course at the local community college. Despite her extensive background in the field, she had remained largely ignorant of cameras and darkroom technique, and what she needed most at that point was the knowledge of how to use all the fine equipment left at her disposal.

So, here we are, almost twenty years later, with not one but two photographers in the Bullock family. That Mom would not have become a photographer if it had not been for her life with Dad is undoubtedly true. It is also true that the heritage of his work is clearly evident in her own.

At the most obvious levels, she uses almost exclusively black and white film, her primary explorations are of the natural world, and her images are evocative rather than documentary. At more subtle and complex levels, Dad's photography, in the most inclusive sense of the word, has been a wellspring in her development as a person. As she is the first to admit, she is both proud of and grateful for the ways in which her legacy from Wynn Bullock has enriched the quality and meaning of her life and, therefore, her work.

This, however, does not mean that her photography is simply a reflection of Dad's. Just as she was as a marriage partner, Mom is quite distinct as an artist, and what she does and how she does it bear the marks of her own unique being.

Both personally and professionally, Mom is about as physical, extroverted, and nonverbal as Dad was intellectual, introspective, and verbal. Those well acquainted with both of

them know it is almost as challenging to get Mom to reflect or comment on her photography as it was to get Dad to stop thinking aloud about the ideas that were an inextricable part of his. Yet, these are some of the complementary qualities that contributed to the success of their relationship. And, of course, such differences are also what have helped distinguish her vision from his.

Other distinguishing forces relate to her openhearted nature. Although Mom is still her husband's chief supporter, promoting his photography through slide presentations, exhibits, books, and workshops, her continuing commitment to Wynn Bullock has never interfered with her own art which she has pursued with characteristic persistence, vigor, and enthusiasm. Her pride and pleasure in his work are as genuine as her dedication to personal creativity is spirited and strong. The abilities to support without resentment and to create without competitiveness are essentially nurturing ones, and these latter qualities are abundantly evident in the images she makes. Add to these a robust sense of humor and a dancer's eye, and a fuller sense of her photography begins to emerge.

❧

To celebrate Edna Bullock as an exciting and accomplished photographer is the principal purpose of this book, and one many feel is long overdue. Over the past ten years, friends, students, and fellow artists have asked with increasing desire, "Where can we buy a book

of Edna's work?" A couple of years ago, the two of us finally decided she needed a better answer than "You can't. There aren't any!" and so this enterprise was conceived.

Our first task was to determine the scope and content of the images to be featured. Since 1976, Mom has been exceptionally prolific, exploring a wide range of subjects, including seascapes, landscapes, knotholes, flea-markets, portraits, and plants. She has also worked with a variety of techniques and formats, an interesting example of which is a rather extensive series of composite images she refers to as "photo-miniatures."

Nevertheless, it is the nude that has engaged her interest most deeply and consistently. Working with the male nude has been particularly intriguing for her and, over the years, she has lead numerous workshops in photographing the nude, primarily in natural environments. She and I agreed it is this work—male, female, and various combinations of male and female nudes—that represents her most distinctive and significant contribution to the field of creative photography to date. This, then, was our choice of focus.

The second phase of our project unfolded as a series of wonderfully serendipitous events. Early in our planning we shared our ideas for a book with Karen Sinsheimer, curator of photography at the Santa Barbara Museum of Art. Having had the opportunity to witness Mom's transformation from quiet helpmate to enterprising photographer, Karen had long been captivated by her story. Although we initially approached Karen for advice, her deep and spontaneous interest in the project quickly led to a much more active involvement.

Her first major contributions were to introduce us to Noel Young of Capra Press and to Chuck Farmer and Jon Simich of the F Stops Here Gallery in Santa Barbara.

Rumpled and bright-eyed, reminding us of a character out of *The Hobbit*, Noel combines an astute business sense with a curious, lively intellect, and a caring, respectful heart. Publishing only what he is attracted to and believes in, he found himself entranced with Mom's nudes and welcomed us and our project with open arms.

As for Chuck and Jon, they operate the only gallery in their region devoted exclusively to photography. Convinced that an exhibit of original photographs to herald the release of the book would be desirable, Karen approached the two entrepreneurs with the idea. Showing them a selection of Mom's photographs, she gained their enthusiastic participation. With Karen as our fairy godmother, we suddenly found ourselves as part of a multi-talented team committed to realizing the project and the synergy began to flow.

Mom and I collected over 300 of her nude images and selected 154 for possible inclusion in the book. These we took to Santa Barbara, along with several copies of a rating sheet I had devised. After helping to spread the images along the walls and floor of Chuck and Jon's gallery, Mom settled herself at a table in the middle of the long, narrow room to watch Noel, Karen, Chuck, and me as we crouched,

knelt, paced, and sat before her photographs, occasionally mumbling to ourselves and independently marking our sheets.

When we eventually joined her to share our individual assessments and finalize the selection for both book and show, all of us were amazed and delighted by our general agreement.

Not unexpectedly, each of us had one or two preferences that the rest gently but firmly turned down. (Through her ultimate veto power, Mom later overruled the exclusion of one of her particular favorites that can now be seen on page 75.) As a group, we also reluctantly eliminated several strong images because of reproduction problems and unsuitable formats (diptychs, triptychs, and other composite images whose impact would be lost on the printed page). Another limiting factor was space and, although Mom has several interesting series, we decided there was room for only one partial set, the four images from *David and the Dunes* on pages 34–35.

These disappointments notwithstanding, the five of us were pleased with the outcome of our afternoon's efforts—a collection of 73 of Mom's finest images. And when my husband Gene returned to pick us up for dinner, he placed what I now recognize as the capstone on a most remarkable day. Seeing us all grinning at each other, surrounded by Edna's nudes, he exclaimed, "That's it! *Edna's Nudes.* There's the title for your book."

Although I was the one who immediately questioned its suitability — it somehow didn't sound *proper* enough—I had to admit it did fit

Mom to a T. Noel, Chuck, and Jon, who had just recently met her and had been freshly impressed with her unpretentious vitality and practicality, loved it. Mom simply chuckled, and Karen with a shrug asked, "Why not?" As it has turned out, I have come to love it, too.

As our project continued to live, it developed in other interesting and unanticipated ways. From the beginning, it had been our intention for me to write an introductory piece that would acquaint readers with Mom's emergence as a photographer at age sixty-one, as well as present a rationale and overview for the book in its entirety. Due to the rich evolution of the project itself, however, it became appropriate to document that process, too. After all, it flowed from our relationships with each other and with the book's central character. Such a description would serve as another window through which to see and understand the woman and her work.

Our plan also had assigned me the responsibility of producing a section of biographical notes—a vita emphasizing Mom's photographic achievements. I thought I knew my mother and had scheduled a couple of days for the task. A solid two weeks later, I was in awe. Mom's increasingly selective memory accounted for part of the extra time needed, but mostly, it took so much time because there was *so much* to compile.

To listen to her talk about herself—on the rare occasions when she does—Mom gives the impression that she photographs "from time to time" and "now and then" conducts a workshop. While I knew enough to recognize

this kind of self-assessment as misleading, I was stunned to realize how inaccurate it truly is: photographs featured in over 100 individual and group exhibitions throughout the U.S. and abroad; teaching, lecturing, and leading workshops for dozens of different institutions and groups; and images included in numerous books, periodicals and catalogs. At a time when many people are slowing down and are either retired or earnestly planning their retirement, Mom embarked on a new career and then proceeded to spend her sixties and seventies living an incredibly active and productive life. It was an inspiring revelation to put it all together.

The next two surprises in our dynamic project related to its expansion. The first was a decision not to mount just a single show to coincide with the release of the book, but to organize a traveling exhibition for which the book (in addition to being a stand-alone publication) could serve as a catalog. I was nominated to take charge of this new aspect of the project, and I now have a much keener appreciation for the challenges of marketing. It is a very time-consuming and sometimes frustrating process to find appropriate venues, but the rewards are exhilarating whenever a good match is made.

Once we confirmed the idea of a traveling exhibition, we all agreed that the opening show, along with the release of *Edna's Nudes*, should be celebrated in Mom's home community of the Monterey Peninsula. We enlisted the sponsorship of the Center for Photographic Art and the Thunderbird Bookshop in

Carmel, selected May 20, 1995, her eightieth birthday, as the date for the festive event, and then scheduled the show to go to Chuck and Jon's F Stops Here Gallery in Santa Barbara. Other early commitments include those made by the Halsted Gallery in Birmingham, Michigan; the S. K. Josefsberg Studio in Portland, Oregon; the museum of the Palm Beach Center for Photography in Del Rey Beach, Florida, and the Sarah Spurgeon Gallery at Central Washington University in Ellensburg, Washington. The schedule of shows and book signings already covers more than a year, and commitments will continue to be sought as long as the project receives the enthusiastic interest and support it has been accorded thus far. "And," as Mom is fond of saying, "as long as I can write my name. . . ."

The second surprise that broadened the scope of our entire project was another inspired idea from Gene—a gift proving to be even more valuable than his first gem.

One day, as I was marveling over my good fortune at having two remarkably talented and wonderful parents, I shared with Gene how grateful I was for the opportunity to work on this project and through it, to really contemplate the person my mother is. I described it as a process of discovery and knowing, as well as of thanksgiving — a process I had learned to value as I worked on projects involving my father's life and work — and Gene responded with, "Why not share the joy? Give others the same opportunity and see what happens."

I took Gene's advice and mailed letters to

about 200 of Mom's models, students, family members, fellow artists, and other friends, acquainting them with our project and inviting them to share a thought, feeling or reminiscence they had in relation to her. "Write from the heart," I encouraged, and people complied.

Over half of those who received letters responded with poems, anecdotes, acknowledgments, vignettes, and an interesting assortment of other kinds of writings. Many included snapshots of themselves or pictures they had taken of Mom. While the style of the written contributions varied widely, the vast majority bore the stamp of being carefully crafted, and it was evident that the process I had described to Gene had been lovingly applied. As one correspondent observed, "We seldom make the time or effort to tell someone how we really feel and what they mean in our lives. Thanks for giving me the chance to do this with Edna while she's still alive. You've offered me as much of a gift as you're inviting me to give!"

With the number and extent of the individual contributions submitted, it has been possible to include only a representative selection in our book. Anticipating this likelihood, I had alerted everyone to it in my letter, along with the assurance that each and every offering would become a valued part of a commemorative album to be presented to Edna as part of the festivities on her eightieth birthday. Even without this foresight, however, we now know with complete certainty that the quality and spirit of people's responses would have

demanded such a presentation.

In the course of selecting and excerpting contributions for the book, I was struck by how similarly Mom is portrayed by such a markedly diverse group of people.

Over and over, people refer to her ready smile, welcoming hugs, and lively eyes. All her models talk about the respect and consideration she accords them and the feeling of partnership they enjoy with her. Family and friends alike note her honesty, energy, and style, along with her occasional sharp tongue, loud voice (she was a physical education teacher long before she was a photographer), and impatient outbursts.

For me, all these commonalities lead to the realization that Edna Bullock is very much her own person, being herself with everyone in the same open, direct way. It has been a joy to see my mother through so many eyes and to discover that what I love about her, others do, too. Perhaps even more importantly, the perspective they represent has encouraged me to shed some of the baggage that inevitably accumulates between parent and child. And now, with even greater awareness, I can agree with so many others that "Edna is truly a wonderful role model."

⁂

With Karen Sinsheimer's self-appointed role of fairy godmother so adeptly performed and her skill in print selection so generously shared, Mom and I, at the risk of being greedy, asked for more. We realized Karen, as

both a museum curator and longtime family friend, could view Mom's photographic career from a very special perspective. She agreed to write a piece sharing a bit of her personal history with Mom as well as some of her responses to Mom's photography, particularly the male nude. She envisioned it as a contribution like the others we had solicited, except with more substance. The others on our team welcomed this addition to our text.

Karen then went on to guide the sequencing of the images for the book—a role she graciously admitted was natural for her to assume. Her first step was to invite Kimberly Macloud, a professional artist and graphic designer from the Santa Cruz area, to participate in the process.

This time, we spread all 74 images—including the one Mom insisted on putting back in—around the entry, living, and dining areas of Gene's and my home. As she had done once before, Mom ensconced herself smack-dab in the middle of things and listened and watched as Karen pursued theme and flow; Kimberly attended to tonalities, shapes, and movements; and I tuned into feelings and meaning.

We complemented each other well, and time became suspended as we submerged ourselves in Mom's imagery. Occasionally we surfaced to the sound of a satisfied hum or the sight of a wrinkled nose and shaking head. Once or twice, we even found ourselves being handed a photograph and firmly steered in a new direction.

At the end of an intensely productive day, the four of us gathered together and Mom confessed, "It never ceases to amaze me what people can find in my photographs. Thank goodness, all I do is make them!"

A few days later, I made a startling discovery: on the whole, I like Mom's nudes better than I do Dad's. Of course, there are several nude images of his I admire and treasure, among them, "Child in Forest" (I remember that one well), "Navigation without Numbers," "Stefan," "Lynne, Logs, and Doll," "Woman and Thistle," "Kay," and "Barbara 1958." It is his other work, however, his landscapes and seascapes of the 50s, the photographs he made in the mid-60s, the final group of images he produced in the early 70s, and, above all, his conceptual, philosophical work that I most deeply respond to and value.

Edna's nudes move me at similar levels. Within this single body of work, I find remarkable depth and variety that stimulate my eye, my mind, and my heart. Her photographs include people of different sexes, ages, races, sizes, and conditions. The immediacy and intimacy of her images draw me in, and I'm held by the wonder and respect I find there. I love her strong kinetic sense—I truly am my mother's daughter in this respect—and I relish her humor. The feelings and meanings many of her pictures evoke within me are powerful and lead me to new degrees of awareness, appreciation, and understanding. In short, Edna's nudes enrich my life in a multitude of ways, and they invite me not only to honor the person I am, but also to become more of the person I can better be.

To celebrate Edna Bullock as an exciting

and accomplished photographer—yes, that is the primary purpose of this book. Yet, to do so means first celebrating Edna Bullock as a human being.

At eighty, Mom is a woman who laughs a lot; who loves to dance, party, and play (somewhat more sedately than she used to); who enjoys deep friendships with her children and their families; who is adored by peers, teens, and tots alike; and who is still growing and creating in a career she began in her early sixties. She is currently producing a new body of work on fences, gates, walls, doors, and passageways. At eighty, her story is still unfolding. . . .

BARBARA BULLOCK-WILSON
Carmel Valley, California

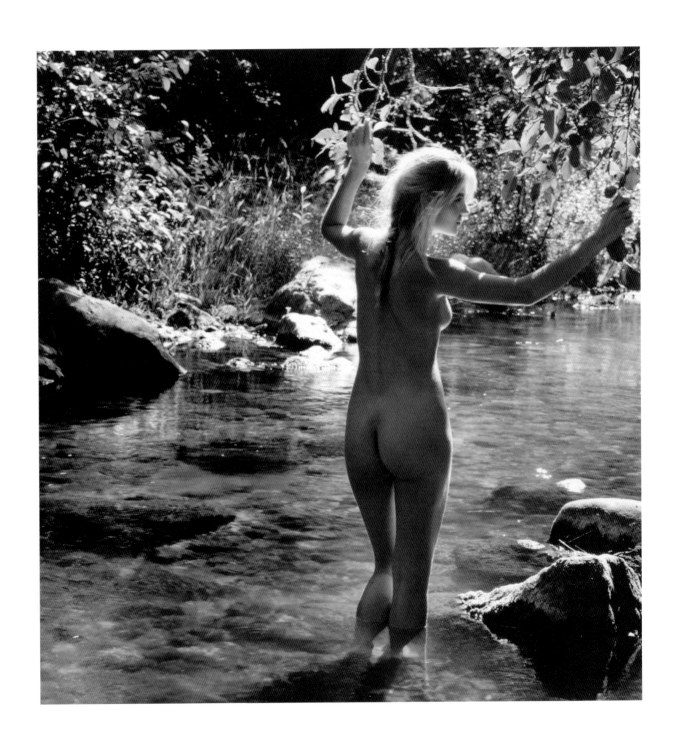

1. Nude in Stream, 1988

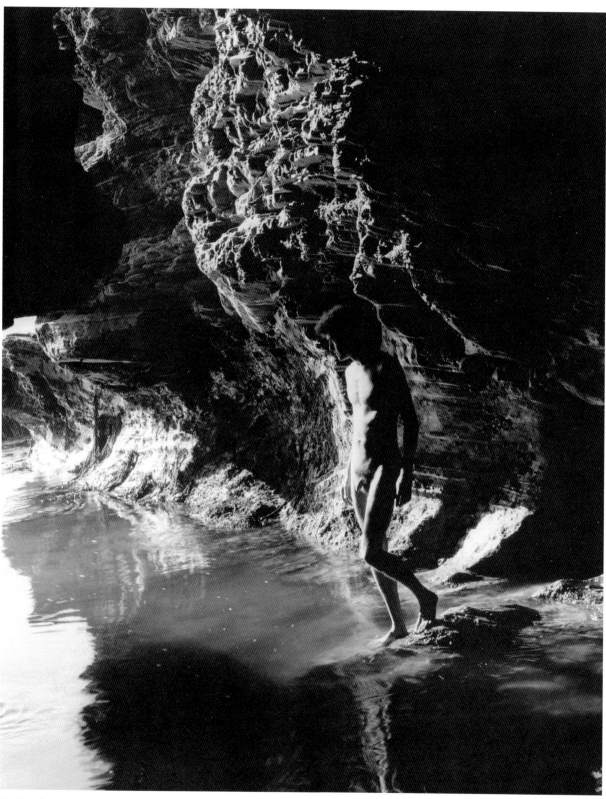

2. David in Cave, 1984

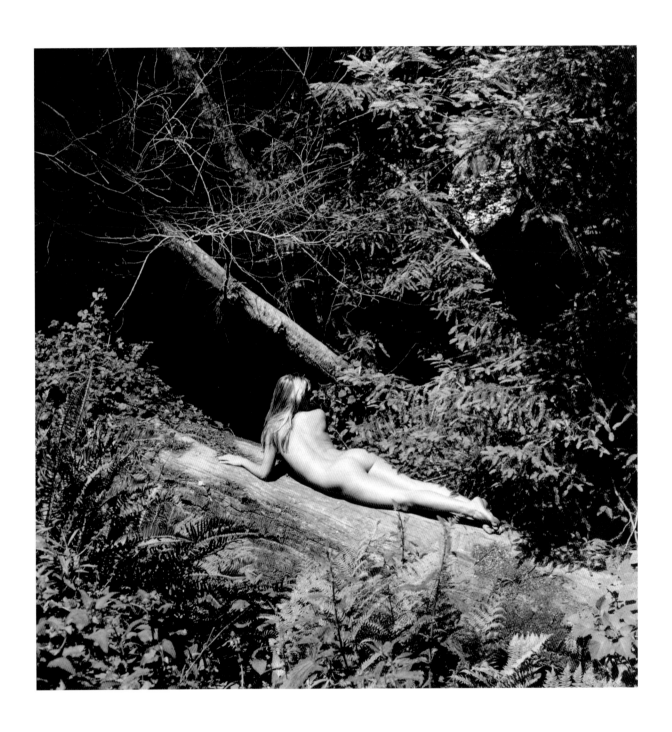

3. Julia on Log, 1988

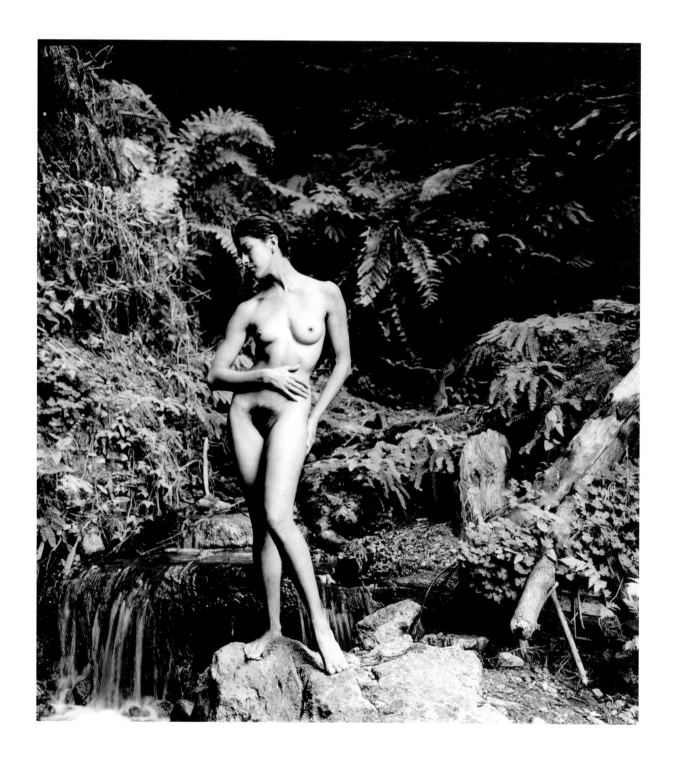

4. Michi, 1993

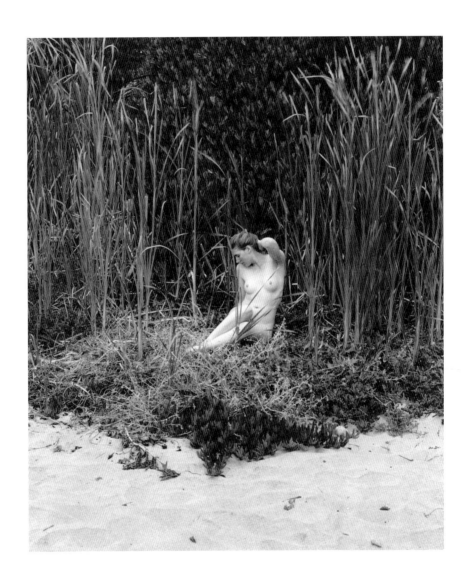

5. Nude in Tall Grasses, 1987

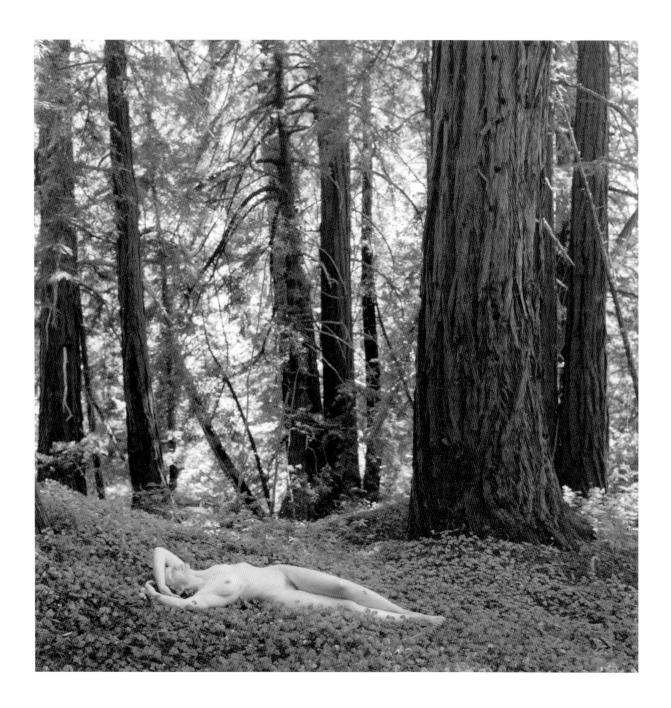

6. Jane in Forest, 1988

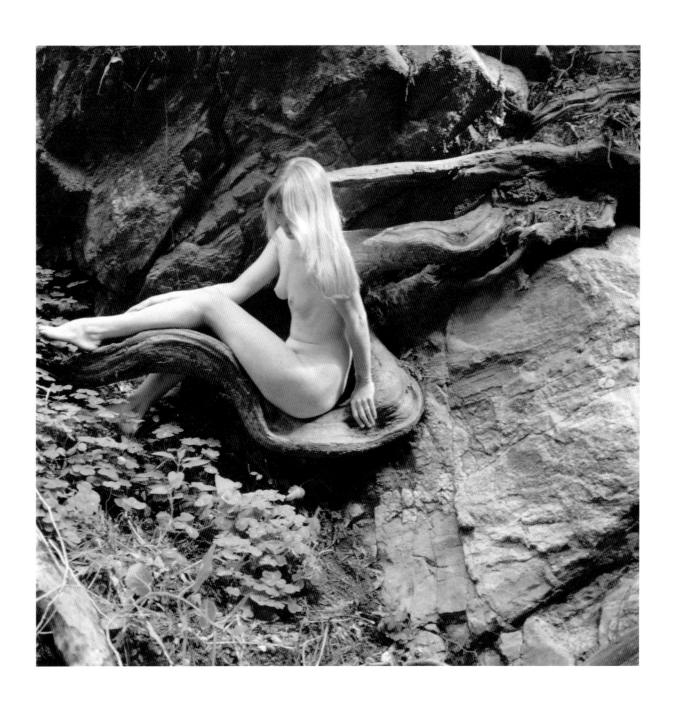

7. Inge on Root, 1992

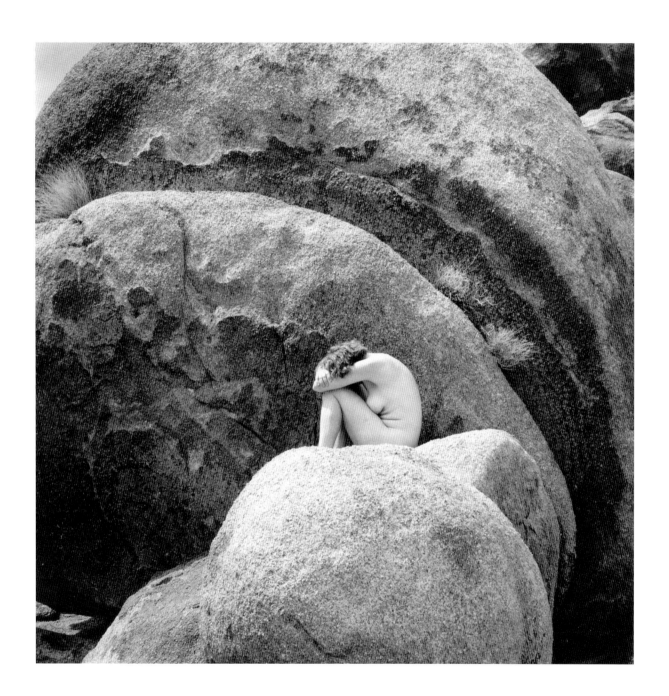

8. Peggy and Round Rocks, 1991

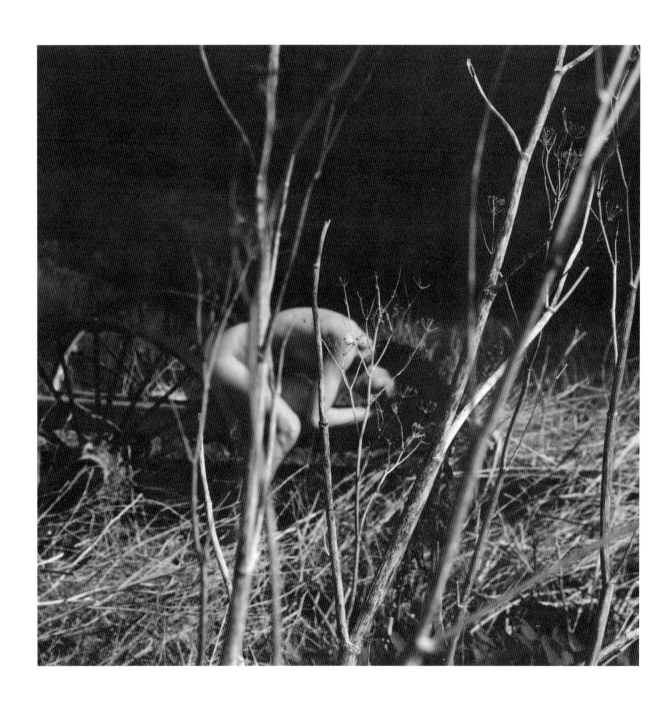

9. Nude on Rake, 1991

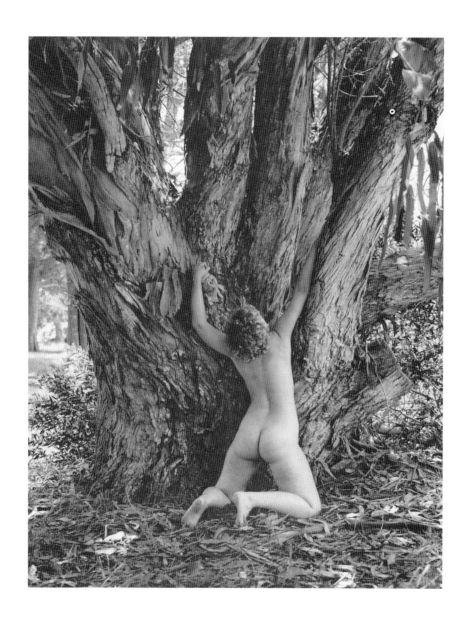

10. Nude and Tree, 1982

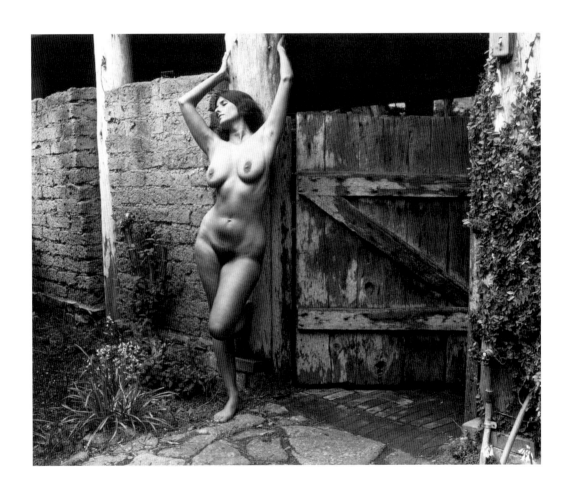

11. Linda by Gate, 1979

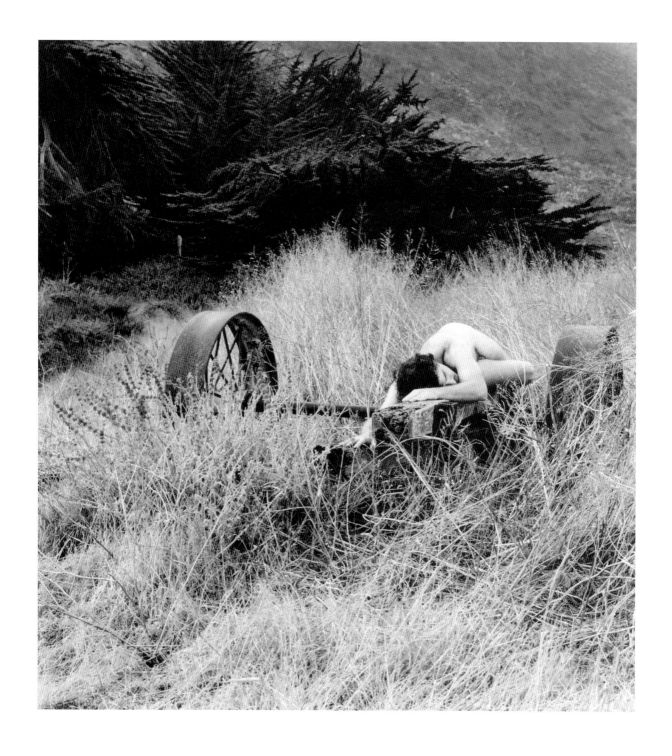

12. Steve, 1990

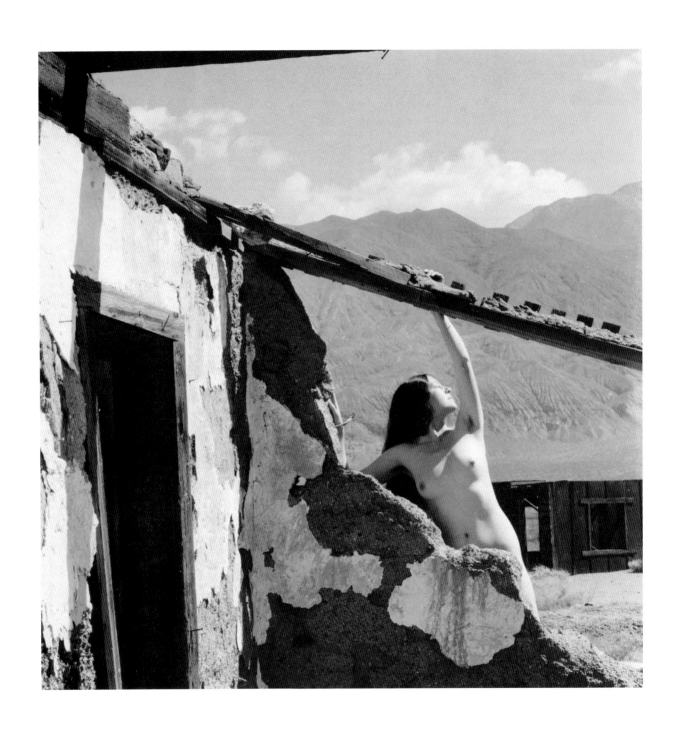

13. Pat, 1990

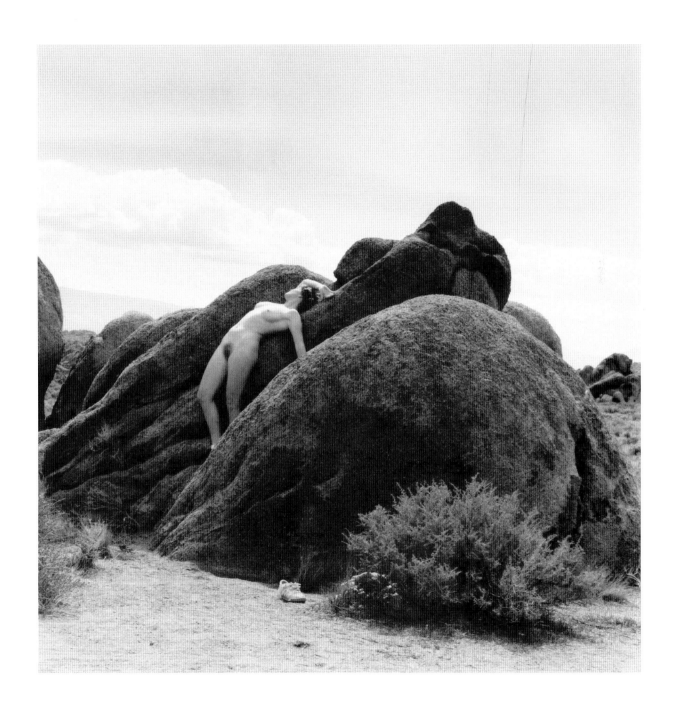

14. Alabama Hills and Peggy, 1991

"...a bridge across death and grief to a new life..."

As a recurrent overnight guest, I discovered that Wynn usually started his philosophical musings at breakfast. One morning, he waved an empty juice glass about in order to demonstrate the importance of light, space, and time.

Edna stood by the stove, one hand on a hip, the other gesturing toward a plate heaped with pancakes. "The time, sir," she announced, "is now, if you want your pancakes before they turn into concrete." I often wondered how frequently her great artist of a husband would have paused to eat if Edna hadn't been there to remind him.

—RUTH A. JACKSON, writer

Edna's photograph, in which a female nude leans against a large stone monolith, has brought so much joy to me over the years. We traded prints years ago, after we taught a landscape workshop in Yosemite. The print of the nude resonates with a feminine strength and stability that I have always associated with Edna from the first evening I met her twenty years ago at a workshop lecture given by Wynn in the Monterey Peninsula College auditorium. I watched her that evening lovingly and carefully assisting Wynn as he presented prints after his lecture. I watched the precise movements of her white-gloved hands as she meticulously moved his photographs. Her image that evening embedded deeply in my mind. Something in the precision of her movements, the depth of her caring, and her attention to detail announced her as special. I knew at that moment Edna was an artist, too!

—WANDA HAMMERBECK, photographer

When you have known someone for thirty years, it is very hard to isolate incidents and memories. Edna has been a number of people in her life: a teacher, a good mother, a loving wife, and in the last chapter of her life, a photographer.

But being a photographer, in some very real sense, has never been separated from being a wife. It was out of her love for Wynn Bullock, out of her wish to remain connected to him after his death, that she took up photography.

In the early days, when she first began to exhibit, usually in conjunction with a Wynn Bullock exhibition, there was considerable criticism that she "was riding on Wynn's coattails." I remember angry conversations with other writers who felt this way, because I knew the truth—that putting her work on a wall in the same gallery with Wynn was her way of walking together with him in this world until she joined him later. Could I say that in a critical review? Hardly.

However, a transformation took place as she worked at photography. She became a directed and competent photographer on her own. Her work reflected almost nothing from Wynn's style. In particular, it reflected her interest in dance, and a very feminine view of the male body. She has put together a body of work that deserves serious consideration in the history of women in photography. She combined her talents from teaching with her photography, and has done many classes and workshops. She is a popular teacher, full of conversational stories and humor.

Wynn would have been proud of her. He would see no connection between her work and his. He was a visionary and an intellect. He would love to see her working at photography, but he would have felt compelled to explain to her why he would have done it differently!

This was their relationship. She loved him unconditionally. One of the major parts of his character was the verbalization of thoughts in process. I remember so often Edna attempting to listen to him while trying to cook supper or make a bed. He would pursue her from room to room, expanding on a theory that had just entered his mind. One of my fondest memories is of Wynn arriving in the kitchen carrying a print fresh from the darkroom. As soon as she heard his voice, without even glancing over her shoulder, she would say, "Don't drip water on the floor, dear". . . knowing full well he had dripped water all the way down the hallway and into the kitchen!

Theirs was a unique partnership. His life in photography was the impetus for her life in photography. She was always her own person in the marriage, and her photography has been her own. Whatever one believes about the hereafter, Edna believes Wynn walks beside her, now as in the past—dripping water on the floor and explaining the philosophy of inner light in all objects.

—Joan Murray, photographer, critic, and ASUC Arts Studio Director, University of California at Berkeley

One of the things I remember most vividly about Edna was something she said after Wynn had died. She had just taken up photography for herself and she told me that when she went into "his" darkroom for the first time, she could feel him standing behind her. His presence, which she said was so clear and warm, was very comforting and flooded her with confidence. She knew she had made a good decision.

—Betty Walker, friend

Edna and Wynn were, in my mind, such partners that I assumed Edna knew all there was to know about photography. In 1976, to find her enrolled in my basic photography class at MPC was a shock! After I learned she had never worked in the darkroom, we enjoyed a great semester together, Edna giving much to the class herself and patiently answering students' questions about Wynn.

—Henry Gilpin, Instructor of Photography, Monterey Peninsula College

In 1980, I photographed Edna as part of a series on artists in their own spaces. In one picture, Edna is standing in front of several posters and announcements bearing the name Wynn Bullock, and this photograph has received a great deal of flack from self-identified feminists. The argument is that Edna is pictured in Wynn's shadow, so to speak. Edna does not feel this is the case. As she says, "This is my wall—I put it together and it has special meaning for me. I chose to stand in front of it."

—Kurt Fishback, photographer

Edna brought a portfolio to the house one day and asked me to look at it. She didn't want the usual praise, she really asked for and wanted honest criticism. It was a series about knot holes, and it was pretty damned good. I knew she had begun to photograph, but I didn't expect the intensity. Edna was producing substantial work in a tenth of the time it takes most serious photographers. She then became totally immersed: going to workshops, assisting at workshops, and eventually teaching workshops. All this, like above, in a fraction of the time others take. There was no sense of urgency, just a feeling of no messing around, and full steam ahead.

It never entered my mind that Edna was older,

or that she *was a woman.* In my mind, Edna moved from being the quiet and supportive wife of Wynn Bullock to being Edna Bullock, Photographer. And it seemed to happen overnight.

—AL WEBER, photographer

Whenever I went to the Bullock house in Monterey, Wynn and I used to sit in the kitchen and have Campbell's soup, talking about his favorite subject—Space and Time. I always thought everything revolved around what Wynn did or said. He was the great master and guru who knew so much about the art of photography. But then there was this lady who always answered the door and let me in while giving demanding instructions to the dog. She was nice enough but kind of quiet. Then one day, I noticed a gleam in her eye—a kind of knowing look that said, "One day you will see where I am coming from."

A while after Wynn died, she started talking to me about her landscape photographs and her flea market series, and then all of a sudden there they were—THOSE NUDES! At first, I was a little surprised and didn't like them, that is, until about a year later. I mean people really started to respond to all those nude bodies and I sold some to customers who only liked conservative landscapes. We did a show at the gallery and everyone liked Edna's nudes and didn't pay much attention to my ole pal Wynn. Who would have thought—EDNA'S NUDES—and I think Wynn would really like them, too. They're darn good!

—TOM HALSTED, owner of Halsted Gallery, Birmingham, Michigan

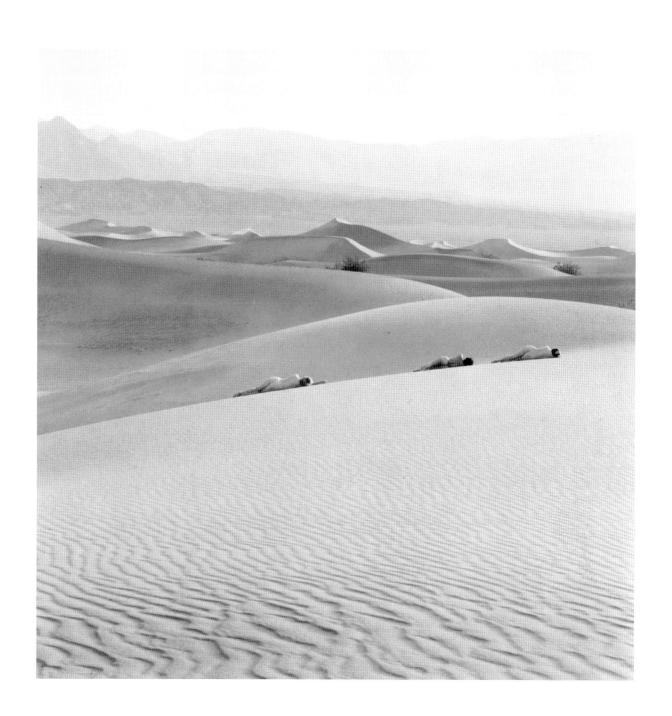

15. Three Nudes on Dunes, 1990

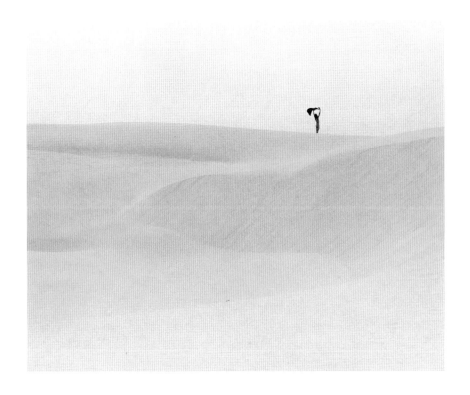

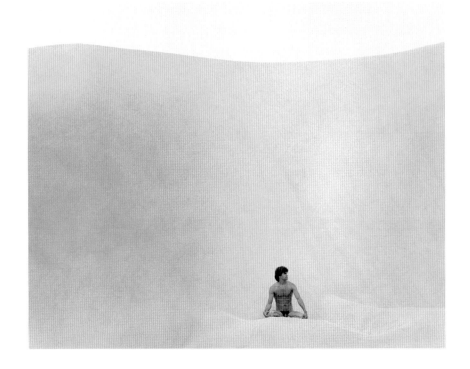

16. David and the Wind, 1983 (top) / 17. David at Oceano, 1983 (bottom)

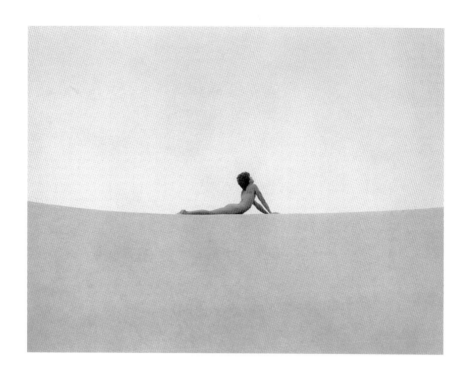

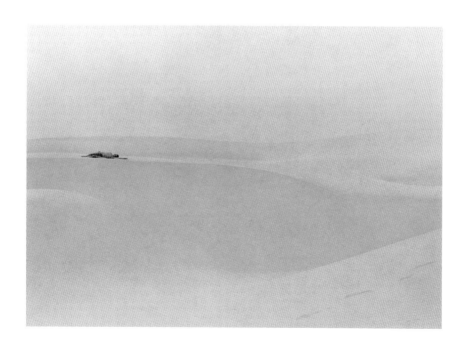

18. David, 1983 (top) / 19. David on Dune Top, 1983 (bottom)

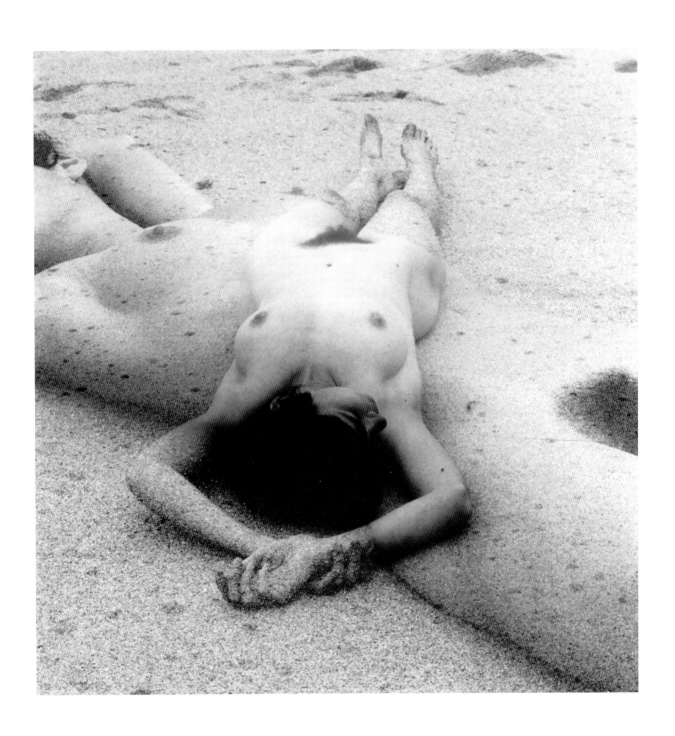

20. Cathy, 1987

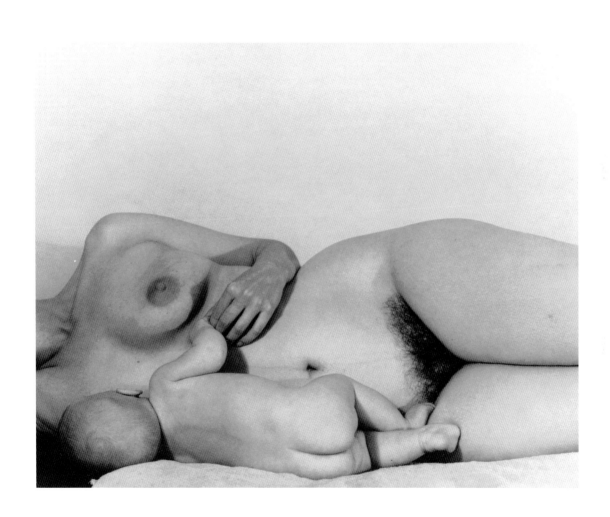

21. Nursing Child, 1986

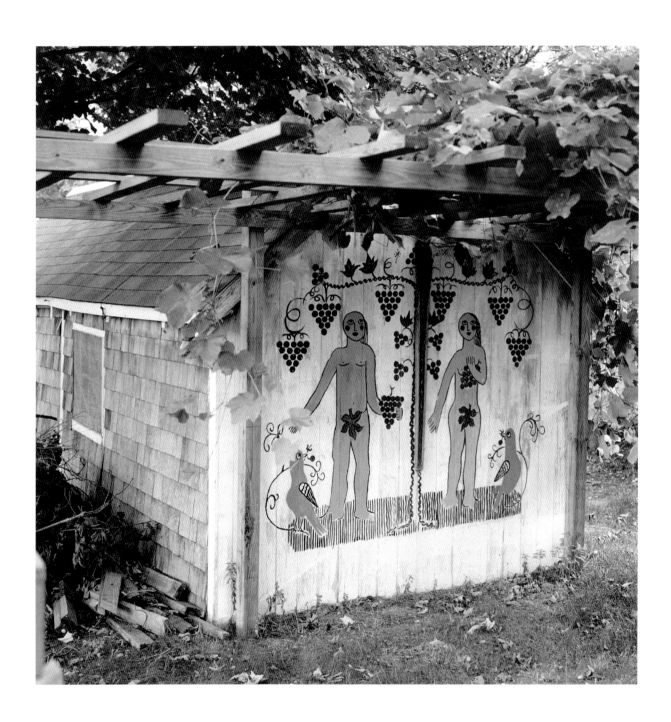

22. Garage Door, Truro, 1986

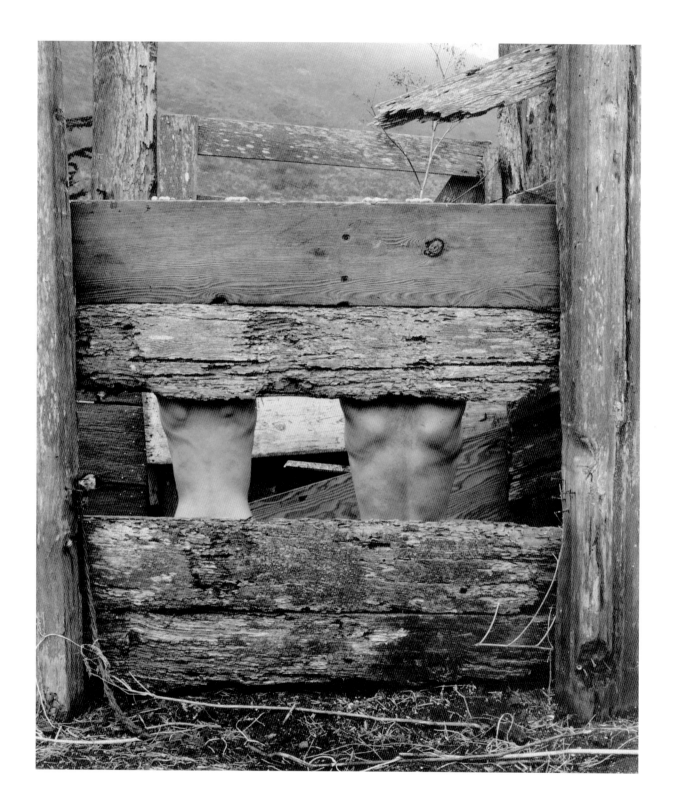

23. Nudes behind Cattle Chute, 1990

24. Flea Market #2, 1980

25. Fisherman's Wharf, 1976

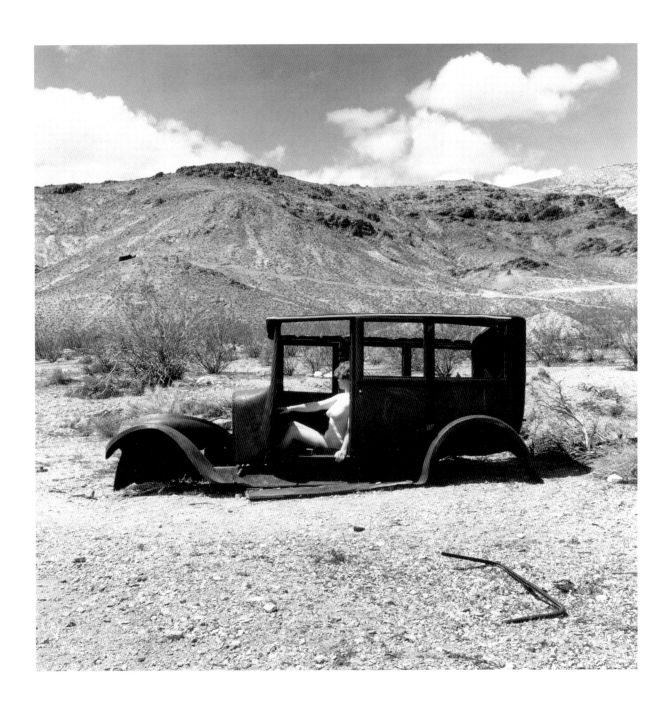

26. Navigation without Wheels, 1991

27. Model at Flea Market, 1987

"...what she does and how she does it bear the marks of her own unique being."

In the early 80s when Edna was taking photographs for my book Combing the Coast, we made many road trips together. Edna really enjoyed driving then, regardless of how many twists a road developed. Sometimes on the open highway, when a macho driver cut in front of us, Edna would smile and floor her turbo jet pedal. As we zoomed past, she would relish the look on that misguided driver's face as he realized he had been passed by a female, obviously over the age of consent.

In addition to that youthful kind of zest, Edna had style. I can see her now in a crisp white long-sleeved blouse, tailored jeans, and matching vest (blouse and vest sewn by her), slim, trim, and ready for work. Then, after a full day of shooting, she would simply add some turquoise and silver jewelry and be ready for a glitzy gallery opening.

Almost fifteen years later, about the only change in all this is that Edna no longer sews.

—RUTH A. JACKSON, writer

I recall a memorable New Year's Eve spent with Edna and others at Pat Ross' home in Carmel (way back when Pat was Pat Friedman). I remember that we all sang along while Pat and I played duets on the piano. As the evening wore on and the music became less structured and more of a "rockous & rollous" nature, Edna began to dance around the room and it became quickly apparent to all present that she was a truly great dancer. I was very impressed by the notion that, on top of all her other talents, Edna was a great dancer!

—HUNTINGTON WITHERILL, photographer

After the opening of the Fotofeis exhibition at Edinburgh University in June of 1993, my wife Pat and I were sitting in a restaurant with Barbara and Lynne, watching Edna demonstrating to her seven-year-old granddaughter Morgan Marie all the various shadow patterns her dinner fork could make on the dining table. Edna —mother, grandmother, friend, and artist. . . .

—RAY WEBB, relative of Edna's son-in-law Gil Harrington (Lynne's spouse)

In 1984, I had just come to the United States from India to study photography and was quite unfamiliar and uncomfortable with the culture. I met Edna at a Friends of Photography workshop in Carmel, and I remember her making a very special effort to get to know me and my work. Strange as it may sound, Edna's warmth, friendliness, and concern prompted me to stay on in this country—a society and culture quite alien to me. At the time, I thought, "If people like her exist in this place, it is worth considering living here."

—VASANT NAYAK, photographer

I first met Edna Bullock in the spring of 1991 while arranging a joint exhibit of her work and that of sculptor Ken Wiese. At the time, I had guessed she was in her mid-sixties, although I later learned I was short by a good ten years.

A handsome, vaguely Nordic-looking woman, Edna's hair is snow-white, her eyes a surprising baby blue. Her conversation gives no indication of her work, and she is the least self-important photographer I've ever encountered. Unless you're lucky enough to see her work, you'd never guess she is an artist.

Her everydayness makes her approachable. She greets people at exhibits and everyone just says, "Hi, Edna!" With an inherent youthfulness and undiminished sense of wonder about the world, she really is more of an Edna than a Mrs. Bullock. Although she must have her bad days and occasional ill-health, spryness and curiosity cling to Edna like a fragrance.

—ROBERT REESE, Director,
The Carl Cherry Center for the Arts

My memory of Edna from our meeting in Carmel in the summer of 1992 is of a fierce, luminous sprite—not the kind who jumps out at you from behind a fern, but rather the kind who confronts you in the depths of the forest with an unwavering honesty and piercing insight.

—JANE D. MARSCHING, Editor,
Wynn Bullock: The Enchanted Landscape, Aperture, 1993

Edna exudes a kind of energy that makes me aware of sinew and muscle. I find myself feeling very physical when I am around Edna—aware of my environment. She inspires me to move.

—BARBARA MOON BATISTA, photographer
and Co-owner, Batista Moon Studio,
Monterey, California

Edna is able to evoke subtle qualities and contrasts I have never before associated with the male form. Her years as a dancer seem to be at work in her photography.

She always has had a twinkle in her eye and an infectious laugh. Earthy, practical, and intolerant of any kind of pretense—all these elements are woven into her photography, too.

—NANCY ROARK RUIZ,
calligrapher and teacher

Edna's treatment of the nude (both male and female) is very natural and unaffected. As such, it is really the same as her treatment of any subject matter. Whether she is dealing with a fence, a flea market, or a person, her photographs seem to say to the viewer, "Here's something I've found to be interesting—perhaps you will, too." And if you don't, she's not the slightest bit offended because she is photographing to satisfy her own need for creative activity and not for any form of external validation. She is her own person, following her own path.

—GENE BULLOCK-WILSON,
Edna's son-in-law (Barbara's spouse)

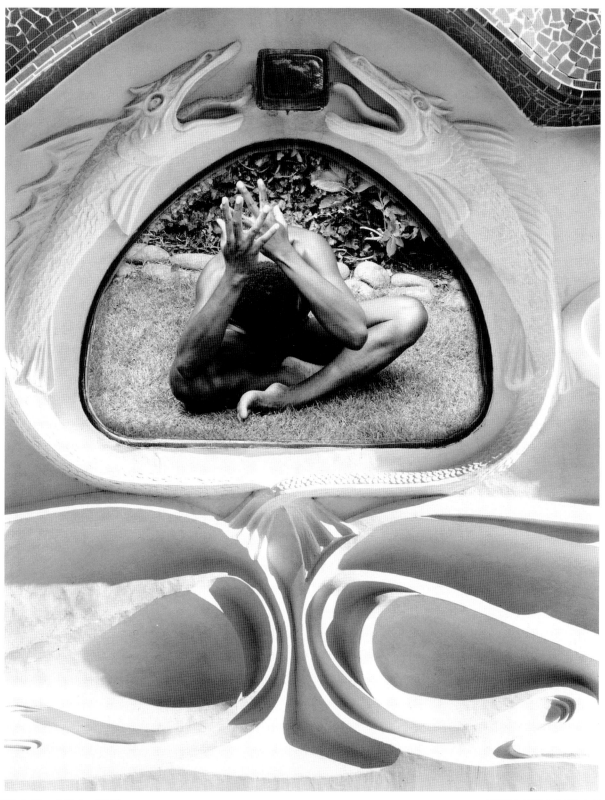

28. Jeff and Fish, 1985

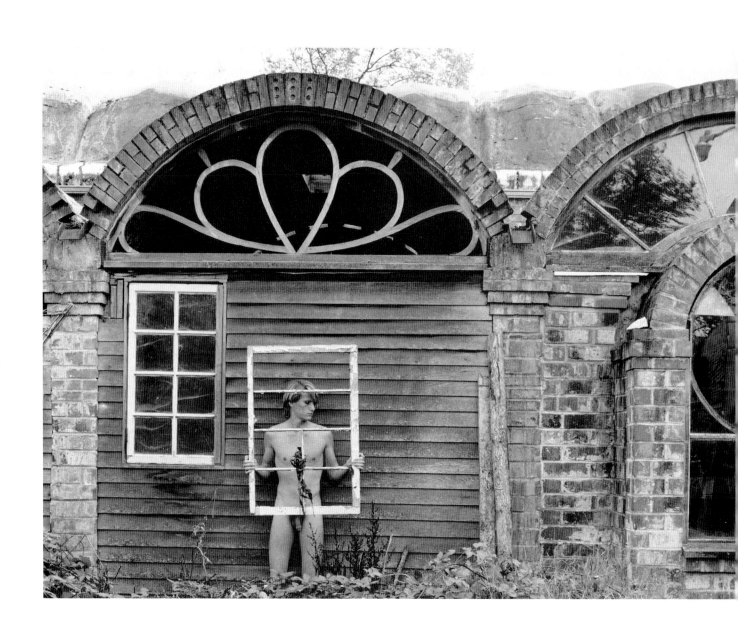

29. Nude and Windows, 1986

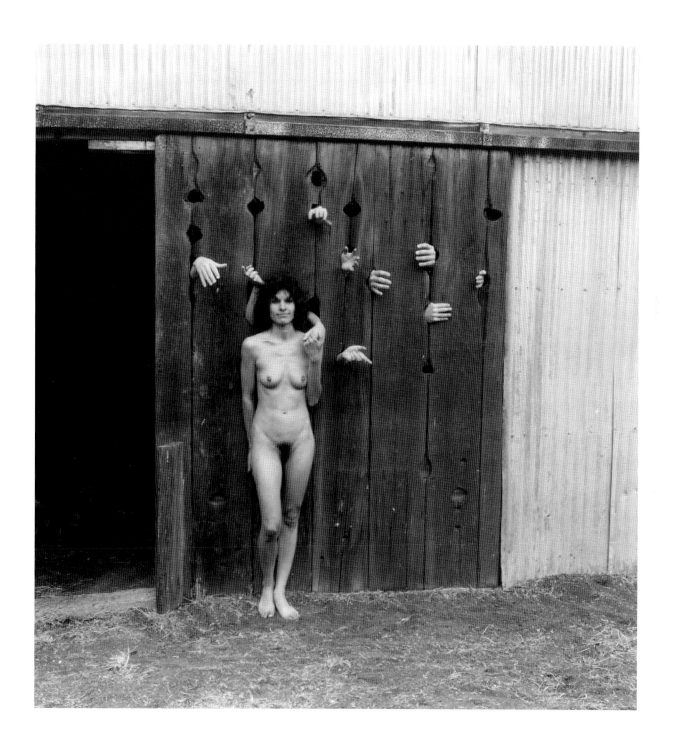

30. Hands and Gloria, 1990

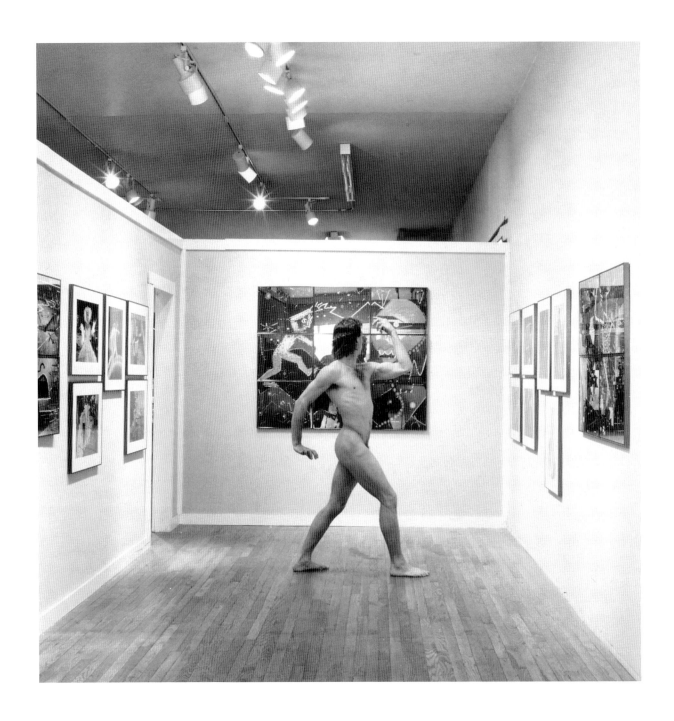

31. Nude in Gallery, 1987

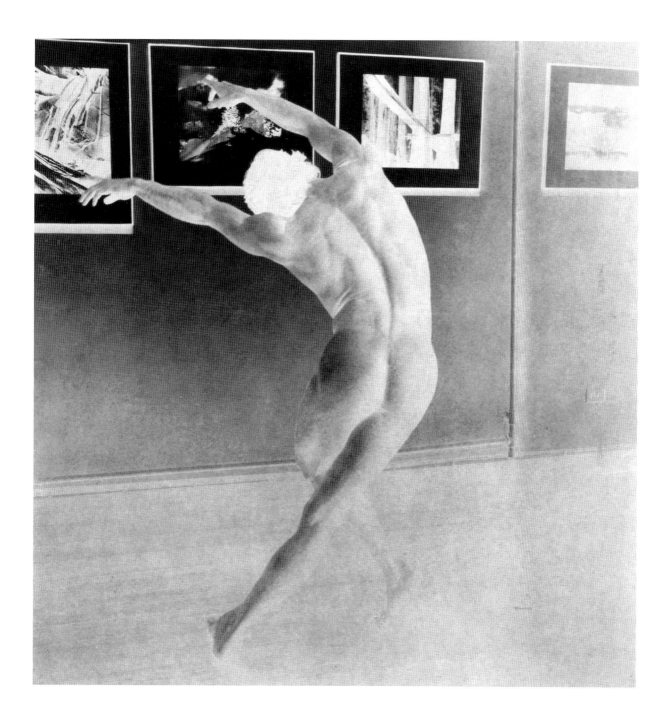

32. Apparition in Gallery, 1987

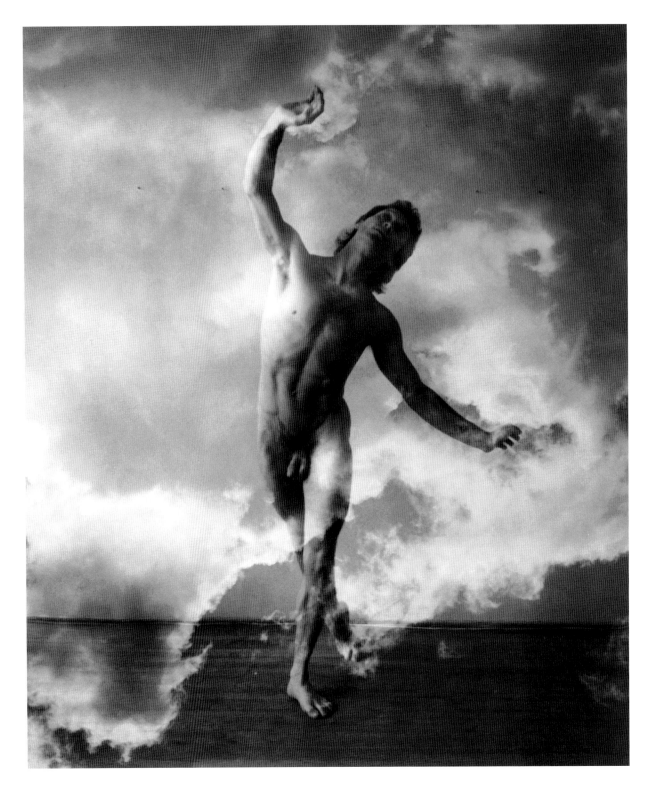

33. Nude in Clouds, 1987

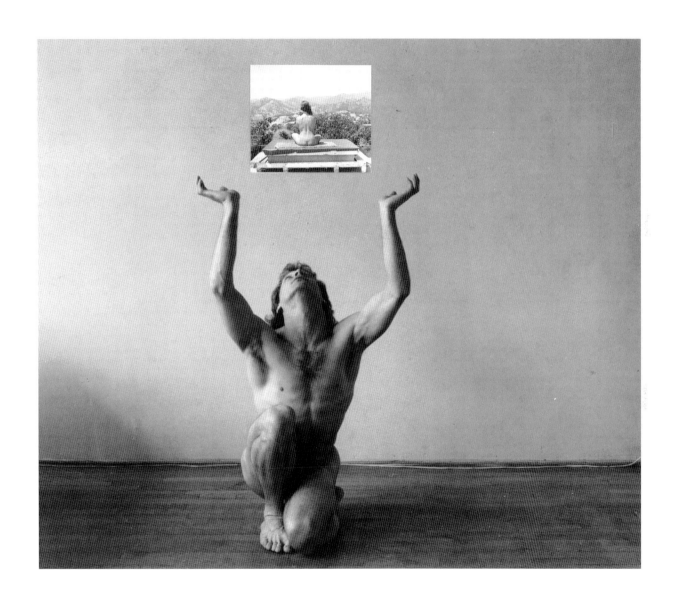

34. Homage, 1987

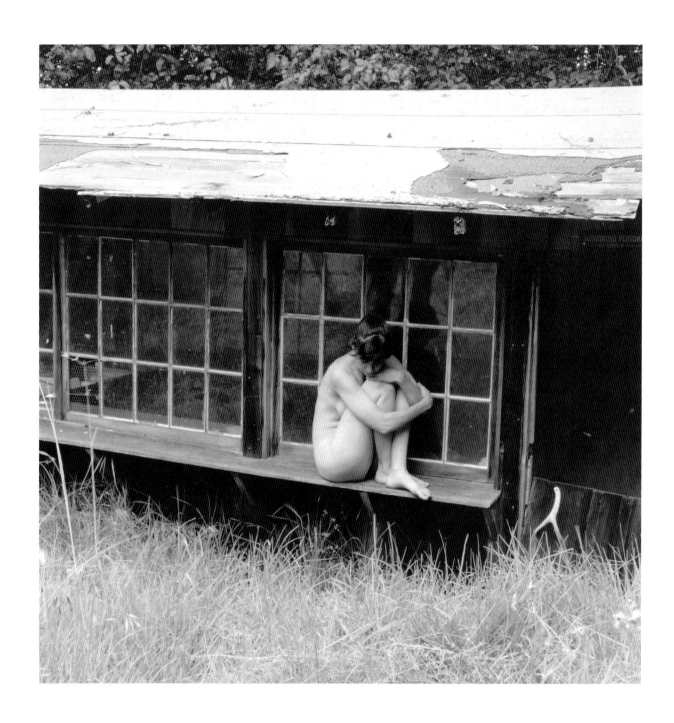

35. Cathy, 1987

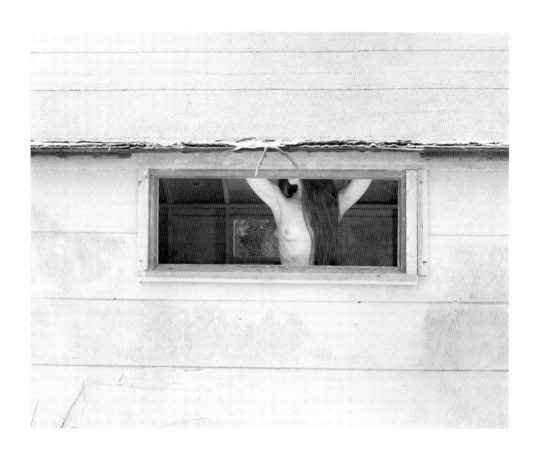

36. Torso in Shack Window, 1982

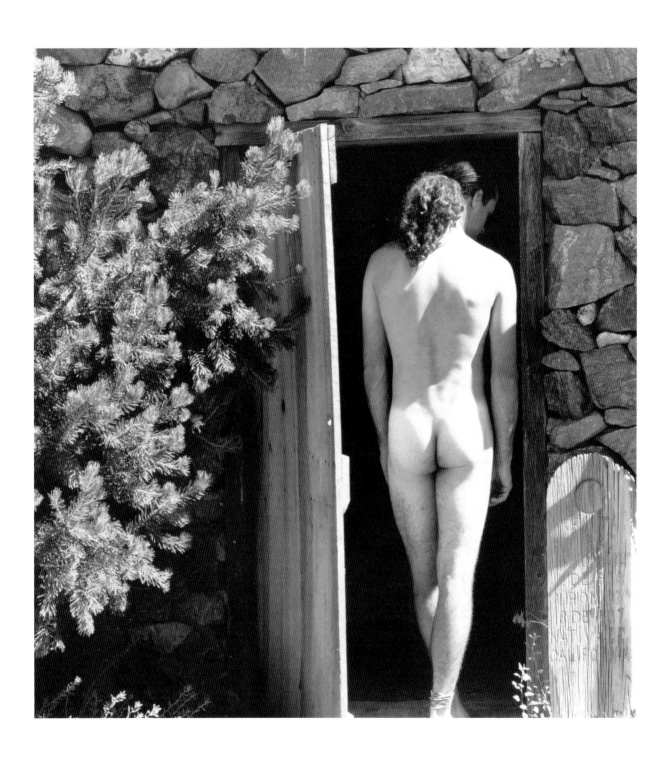

37. DJ at Fellini Estate, 1993

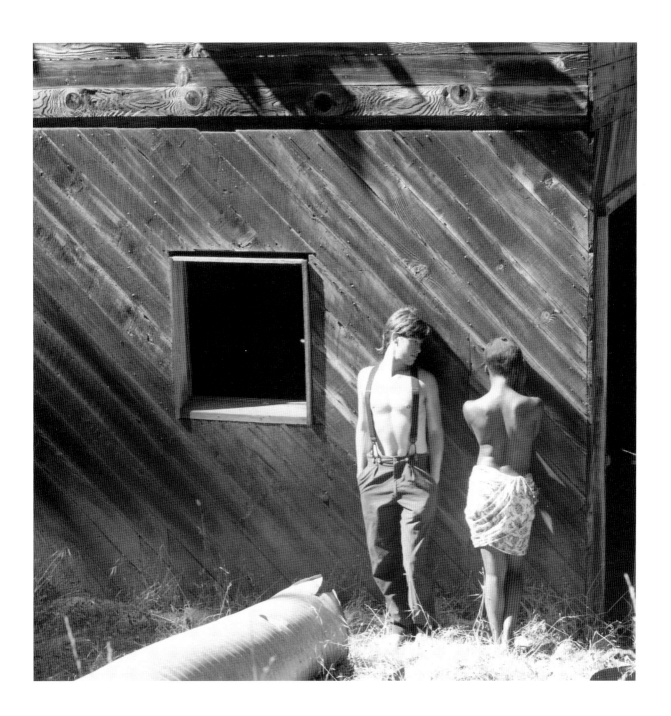

38. Neta and John, 1990

"All her models talk about the respect
and consideration she accords them..."

In many cultures, an elder woman regarded with dignity and esteem would be called "grandmother". . . . This is something I would call Edna.

— MICHI HOLLEY, model

During the 1981 Ansel Adams workshop in Yosemite, I was teaching with Judy Dater, Joel Meyerowitz, King Dexter, and George Tice. For the day when the entire group goes on an outing (a field trip to the high country), Judy offered to present a nude workshop. I believe that we had three models who were hired to be photographed. Only one or two showed, and it was asked if there were any interested volunteers. Edna, who was standing beside me said, "You know what I just realized? It's important for the photographer to know what the models are going through. So I have to model." At that point, she stripped down and ran up to the front of the group.

Talking with her later, she said that it was one of the most difficult things she had done. She also said that the only person around whom she had been naked as an adult was her husband. I was amazed at her courage! I have always carried this with me, to the point that I have, as part of my lectures and assignments, the requirement for students to experience being on both sides of the camera.

— WILLIE OSTERMAN, Chair,
Applied Photography Department,
Rochester Institute of Technology

For me as an artists' model, working with Edna is a pure and fresh experience. Her happiness and joy engulf me and make me feel good about modeling. This feeling of goodness allows me to bring out my own goodness and this, I believe, is reflected in the finished product. This essence of purity and innocence is a very important step in the area of nude photography because the world is so misguided regarding nudity. We all need to approach, as I believe Edna does, the art of photographing the nude with the innocence of youth.

—NETA COBB, model and dancer

As a participant in several of Edna's workshops, I have seen her become impatient with any hint of insensitivity toward models. She supports photographers to face their fears and prejudices about working with a model of the same sex and she consistently encourages her students to develop respectful relationships with all models. In her workshops, not only the product, but the process, is essential.

—VIRGINIA BAILLIE,
nurse-psychotherapist and creative
expression workshop leader

A few years ago, I was posing for Edna at a nude beach south of Carmel, and we made quite a couple: a white-haired lady with the 4X5 camera with a 30-something nude male dutifully following her everywhere. She had brought a pic-

nic basket and after a while we stopped for lunch. We looked like the old Renaissance paintings with the nude ladies on the grass with the fully-clothed males eating food—only with the roles reversed. I remarked about this to her and asked her what she thought people would think about the inequity, whereupon she took off her blouse and sat there with just her bra on, saying, "That's as far as I go at my age."

—GORDON BROWN,
Program Development Director,
Palm Beach Center for Photography
(formerly Palm Beach Photographic
Workshops)

Edna believes in the creative contribution of the model. She watches her models interacting with their environment and often invites them to take the initiative while she maneuvers herself around to find just the right angle or light.

A particular session comes to mind during which the photograph "Jane, Partington Canyon" was made:

As we walk deeper in one of Big Sur's canyons, my heart begins to pound with the pulse of the stream. The boulders ahead draw my energy as I watch the water rush over them. Light dances all around with a spotlight through the trees streaming onto the scene. Without hesitation, my mind plans the approach. Easing into the water, the soles of my feet feel the mossy, mud-covered streambed. My ankles act like thermometers, reading the temperature of the water. While moving through the approach, my mind gives me warm thoughts to protect my body. I pull myself up onto the boulders. With this major movement, my body begins to complement the scene. "Try moving your right arm," Edna indicates in mime and our inner realities connect. My being with nature consumes me as I take long deep breaths. The Moment is complete in thought and very faintly over the rushing water I hear the sound of Edna's shutter.

—JANE MURRAY, former model

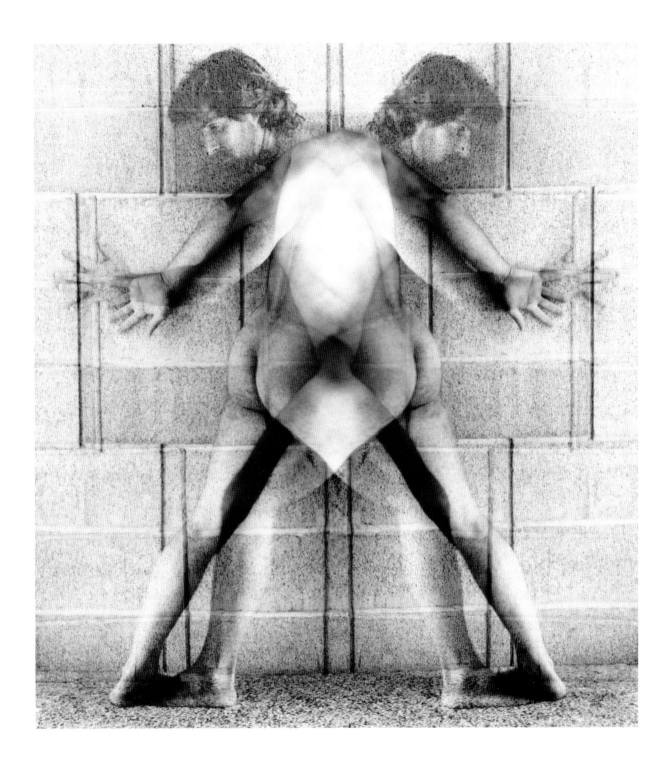

39. Duality, 1990

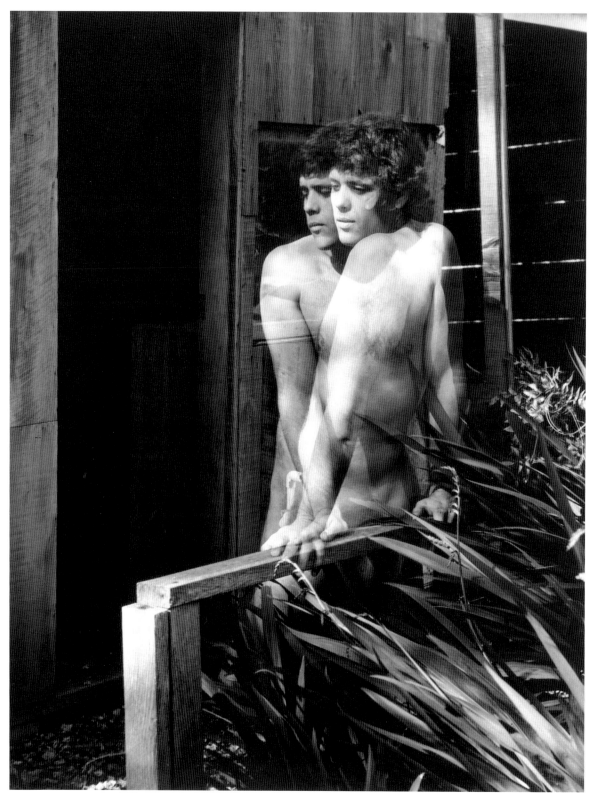

40. Untitled, 1984

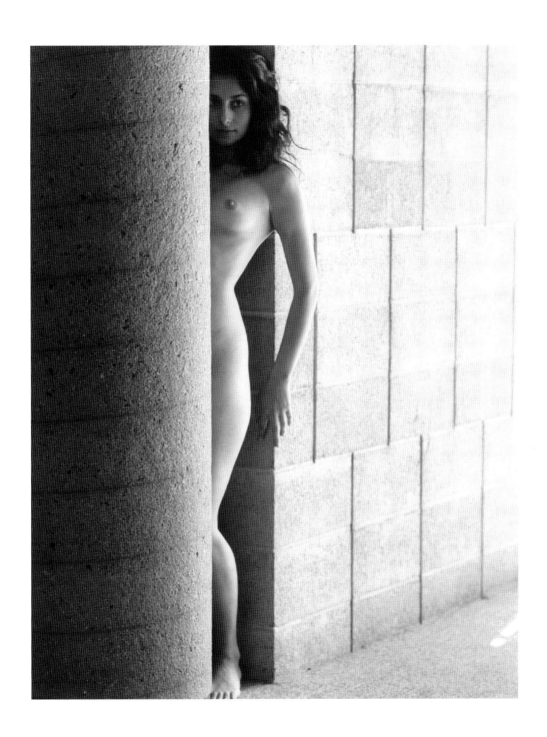

41. Nude and Pillar, 1993

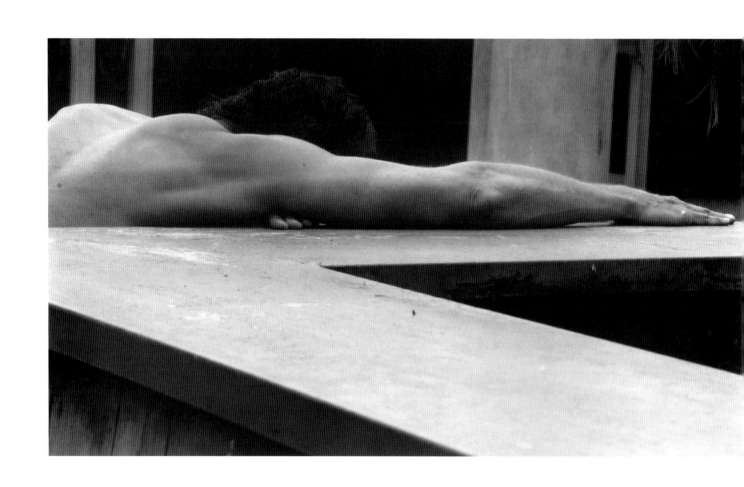

42. Arm, 1991

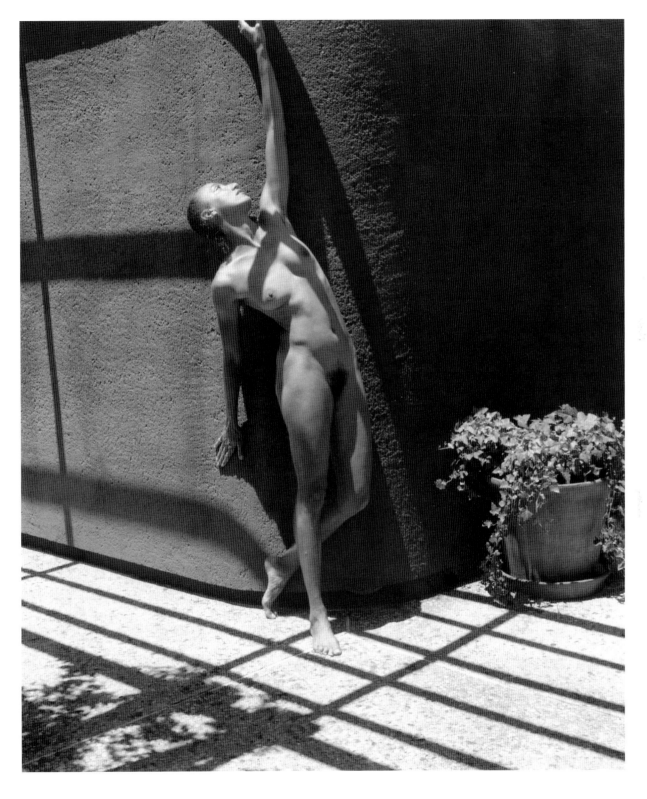

43. Karen, 1989

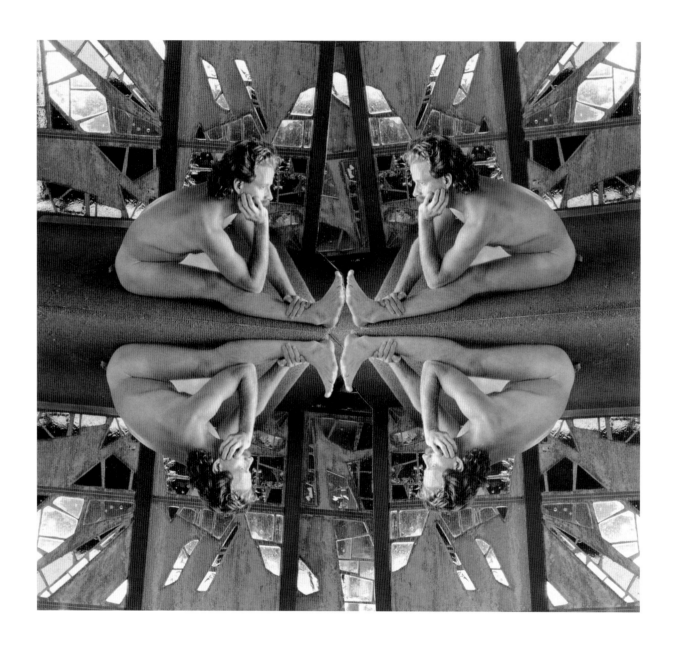

44. Michael, 1987

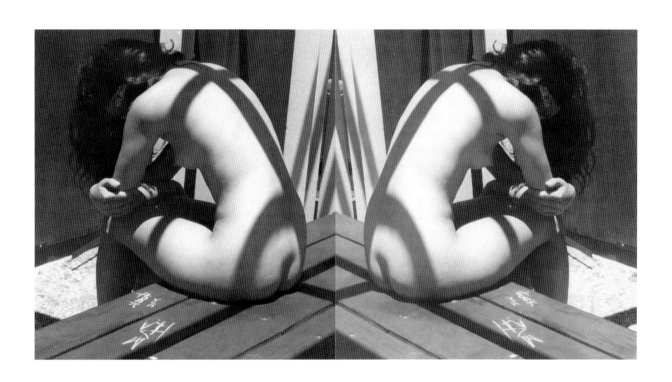

45. Nude on Bench, 1993

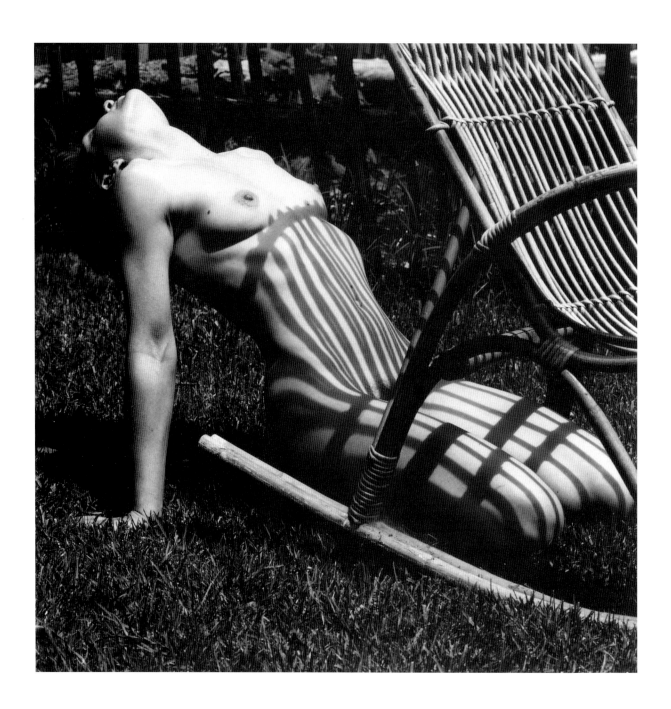

46. Chair's Shadow, 1989

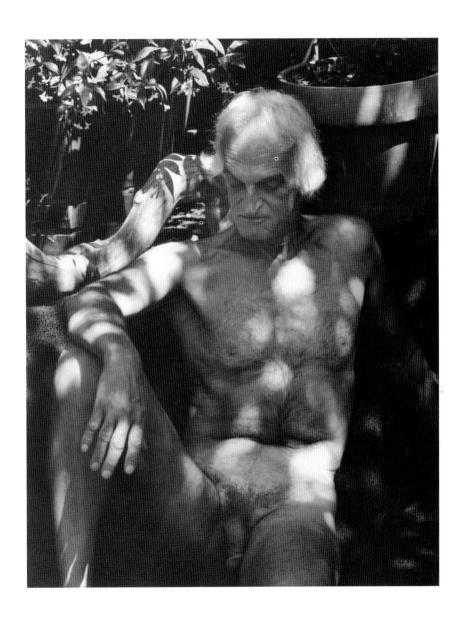

47. Don #12, 1984

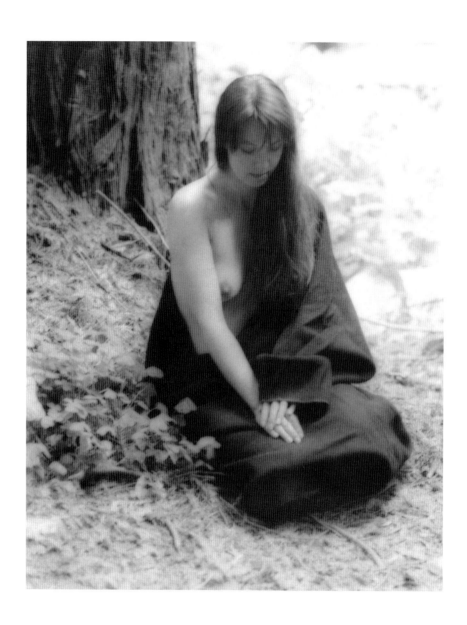

48. Heather Resting, 1989

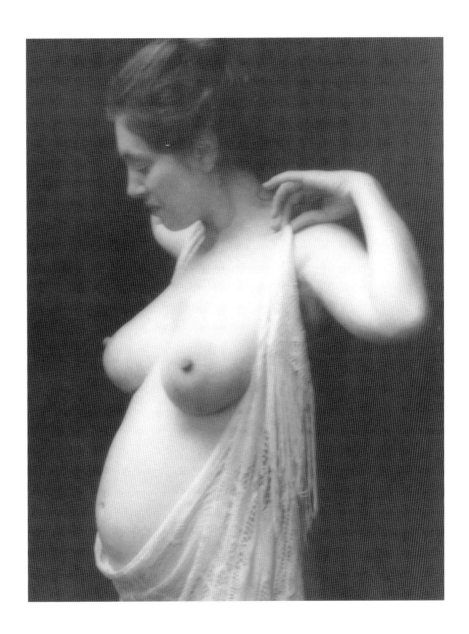

49. Michaelle with Scarf, 1986

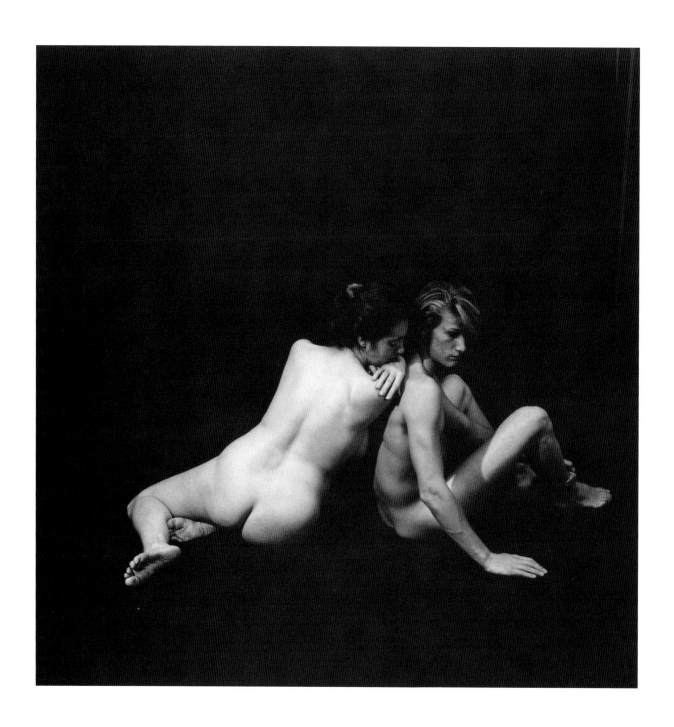

50. Nude Couple, 1986

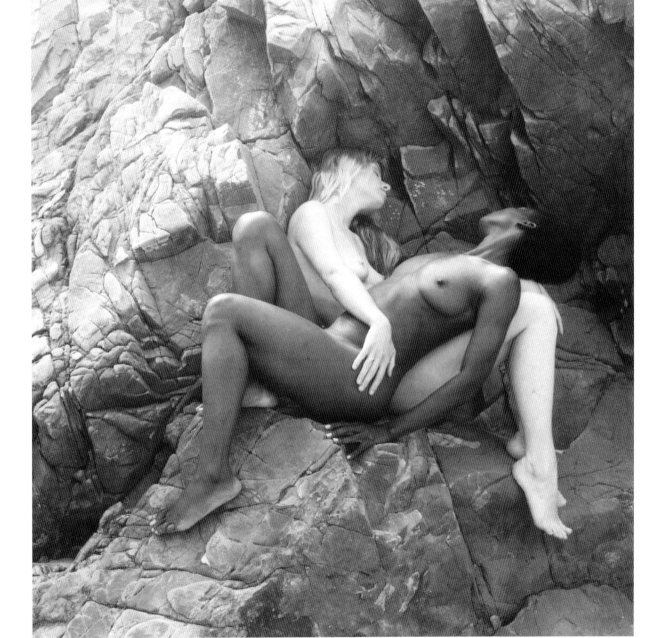

51. Neta and Inge, 1990

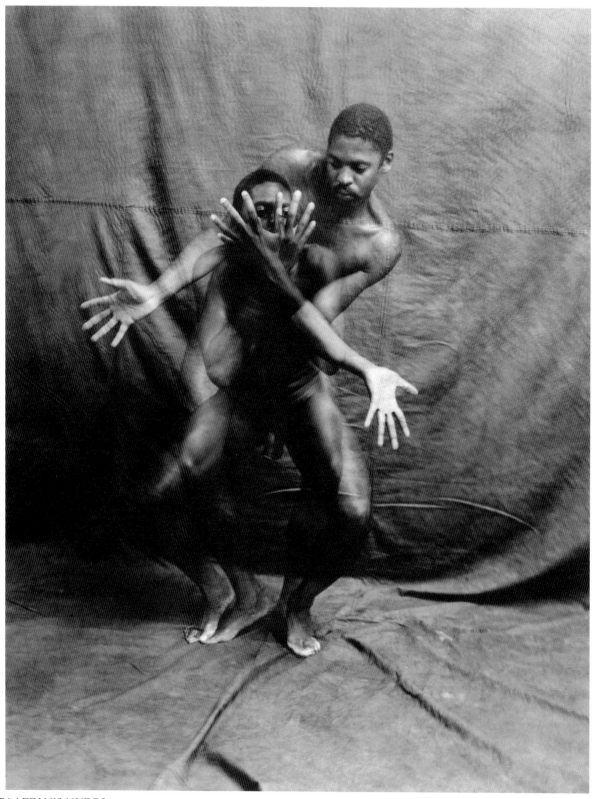

52. Movement #7, 1984

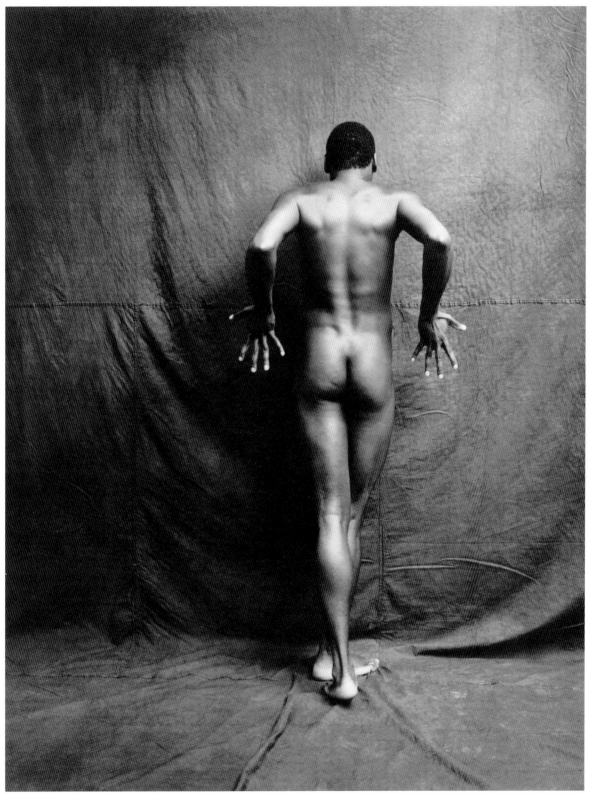

53. Jeff #9, 1984

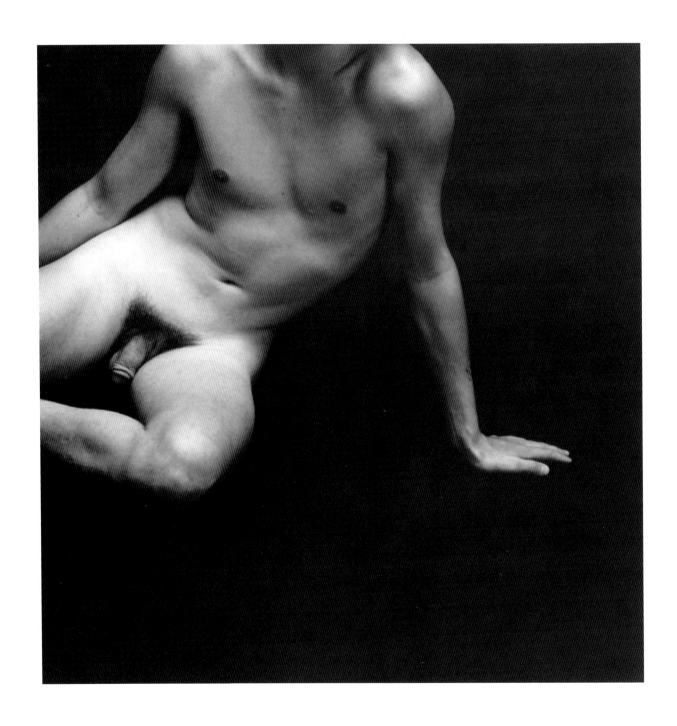

54. Michael, 1986

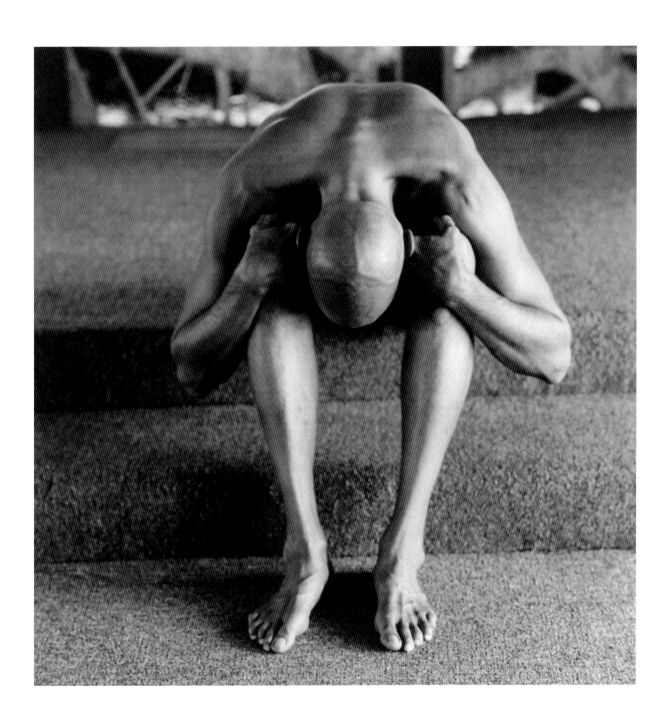

55. Stuart #4, 1992

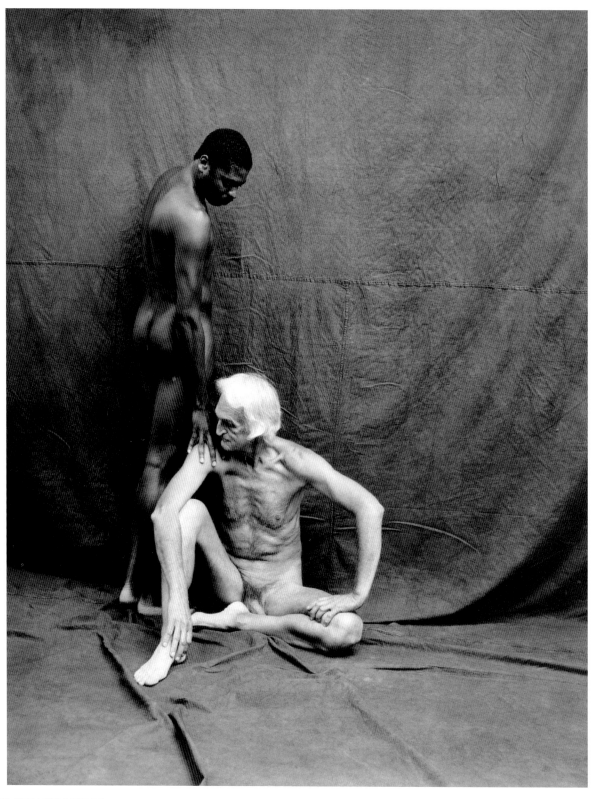

56. Don and Jeff #5, 1984

"To celebrate Edna Bullock..."

Edna Bullock and Wynn did something long ago that changed the course of my life: they let me know that I was worthy of their attention and friendship. I can remember the shy twenty-year-old black kid from Brooklyn who sat in their kitchen, watching them make homemade mayonnaise for my girlfriend and me, sitting and wondering, "Why?"

Like many of my generation, I was in awe of Wynn Bullock's brilliant photography. A student who wants to understand the source of great art often begins by studying the images, as if an answer can be found in the final results of any process. What I began to discover in Wynn and Edna's kitchen was to look instead at the humanity of the artist—that art is the product of a life lived a certain way, a life that includes family and attitudes toward spiritual growth and creative expression.

And so, I will leave to others the interesting and important work of interpreting Edna's nudes. What matters to me is the very fact that Edna felt an imperative to begin serious creative work when she did in her life. We live in a time when there are many reasons for art-like behavior, but there are very few who need to do it as the absolute necessity for a fulfilled life. This is true of Edna and, when you meet her, she brings that with her, along with her warmth, open spirit, and humor.

—Chris Johnson, Associate Professor of Photography, California College of Arts and Crafts

I am amazed when I realize that Edna has been my mother for more than fifty years. She was a bride of twenty-eight and I a neurotic twelve-year-old when our lives first meshed. Through those many years, we have shared warm happy times and a few very difficult passages when we lost first my father and her husband and soon after that my husband.

One of our best times together was when we cut loose from our families and took off on an extended car trip. In 1980, during the gasoline shortage, we decided to take advantage of the law that permitted you to buy all the gasoline you wanted if you were more than 100 miles from home. I picked her up in my new little red Honda and we just headed north with no plans, no reservations, and lots of enthusiasm. On the edge of town, we stopped for whatever goodies we knew would bring looks of reproach from our respective families, and the adventure was begun.

I was armed with fossil locations in northern California and Oregon and Edna, of course, had her cameras. Such freedom! Never before had I been able to say, "Stop the car," and not feel the silent but palpable impatience of someone who considered that an hour of breaking rocks to look for fossils was akin to working on a chain gang. Edna did the same when she saw a likely photographic possibility. This occasionally involved the disrobing of my fifty-year-old body, and since I have never seen any of these photographs, I assume that they were not a total artistic success.

When we decided that we had had enough, we stopped wherever we spotted a likely place to spend the night. We never had a problem

because, with the gasoline shortage, no one else was on the road. We would have a drink of bourbon from our hoard followed by a good meal, read our books, and go to bed. Mostly we just talked. Both of our lives had been so involved with all the other people we loved through these many years that we had never realized how much we loved each other.

— MIMI HORNER, Edna's step-daughter

Edna can find magic in a fleeting moment; she did this for us in a snapshot of our granddaughter Jenny. And she can sculpt life and the world into scenes that feel eternal—as she did in the three nudes on a dune, which hangs on our living room wall.

There is a perception of profound depth in her photography.

What rare vision is it that can catch the wonder of things, and both see and be such beauty?

— MARGARET AND FRED KEIP,
Co-ministers, Unitarian Universalist
Church of the Monterey Peninsula

I have watched Edna's photography blossom and mature, and I have seen the results of her warm contacts with students and models alike. We have sat under the desert sky and drunk wine and talked about our lives, and I value the straightforward honesty and human sympathy which color her life and inspire her photography.

— DWIGHT CASWELL,
photographer and Minister,
Kenwood Community Church

The British historian Sir Kenneth Clark, in his monumental work on the nude in western art, said that the history of art in the west was large-

ly a history of men looking at women. Edna has certainly turned that idea on its ear. It is one giant leap for womankind.

— JACK WELPOTT, photographer

Edna's photographs of the male nude reveal that she honors the person being photographed. There is no exploitation here, but rather a feminine love of the male form which suggests a possible future for both female and male to work together toward harmony. Her work can be looked at not only for the lovely play of light on form, but also for the spiritual qualities of how we fit in with Nature.

— SHIRLEY I. FISHER,
Professor of Photography and
Humanities, De Anza College

I have known Edna since 1981. I have matted and framed literally hundreds of her photos. I love her interpretation of the female form; however, I think her depiction of the male form has even more sensitivity. It is neither brutish nor passive. The forms flow with their environment. They are integrated with their surroundings in a natural, yet distinctive way. Above all, Edna is a humanist in her content and composition. I cherish the privilege and pleasure of knowing Edna the person and Edna the artist.

— SKIP KADISH, Owner, Spanish Bay
Galleries, Pacific Grove, California

One of my fondest memories of Edna is the time we went to the USSR in May of 1991. I invited her to be one of eight American participants (five of whom made the trip) in the first major exhibition of women's photography in Russia. Edna exhibited some of her exquisite male nudes which astonished our Russian hosts, most of

whom were male. Even in 1991, photography of the male nude was virtually nonexistent. But a white-haired "little grandma," as they affectionately called her, photographing young naked men on sand dunes? Unheard of! And for the fifty or so Russia women exhibitors, each struggling in her own way to establish herself in a male-dominated field, Edna and her work were an inspiration.

—Martha Casanave, photographer

I arrived at the annual photography auction of the Center for Photographic Art in Carmel, fully intending to enjoy, certainly NOT TO BID. Intentions were damned.

I was drawn to Edna's "Jeff #9" and never left its side until the bidding was ended. I not only bid to own, I also gave no thought to the very full walls in my home. I simply knew he had to become a beloved part of my collection. Edna is magical: she focuses on his very being, his sensuality, his strength—and has brought to life, for me, this photograph that has its home in my bedroom.

—Nancy Hirsch, art consultant

What has been so remarkable to me over these twenty years has been the constant intuitive oozing out of Edna's soul of image after image, conveying intense feeling and spirit, as well as the strong graphic design elements and tonalities only possible through an expert command of the entire photographic process. Her work is always honest and brimming with clarity.

Edna's warmth and happy heart, her personality, and her love for friends and colleagues have endeared her to all of us who share with her a love for photography as a personal creative medium.

—Dick Garrod, photographer

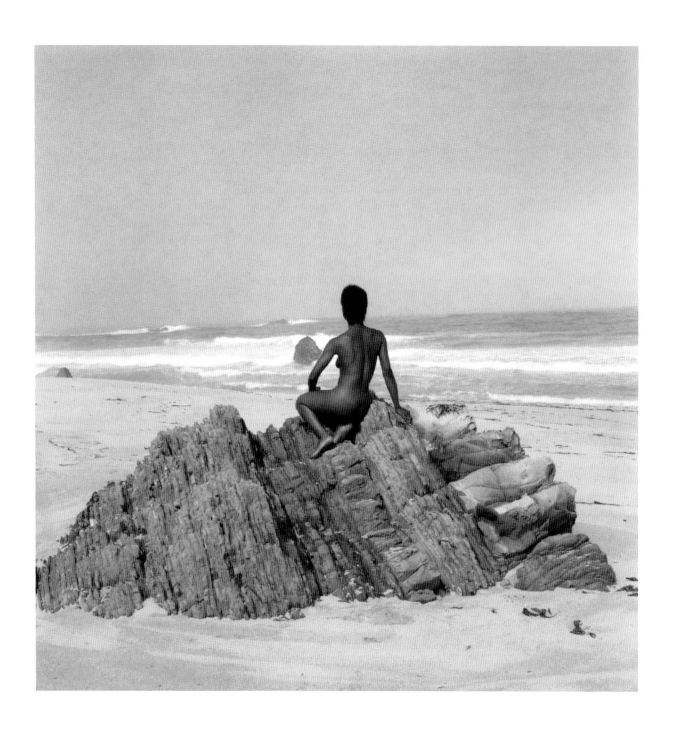

57. Neta, Garrapata #2, 1990

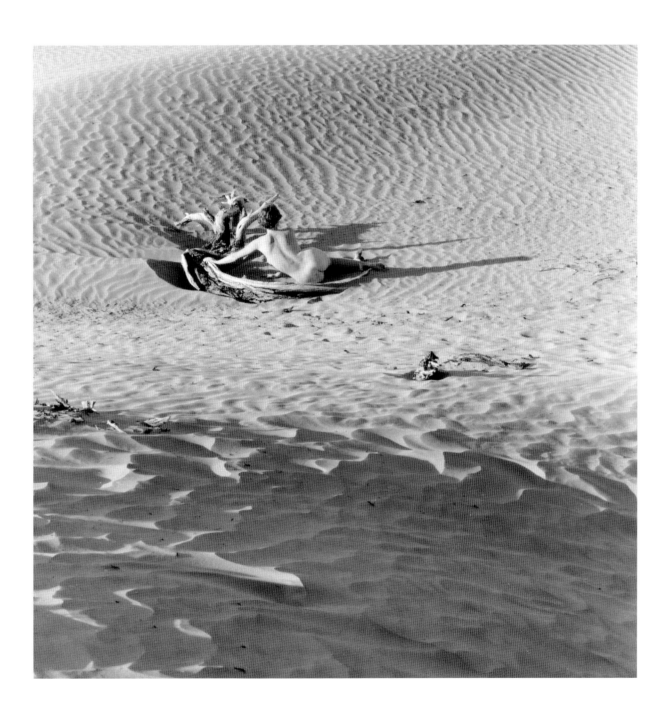

58. Nude and Driftwood, 1991

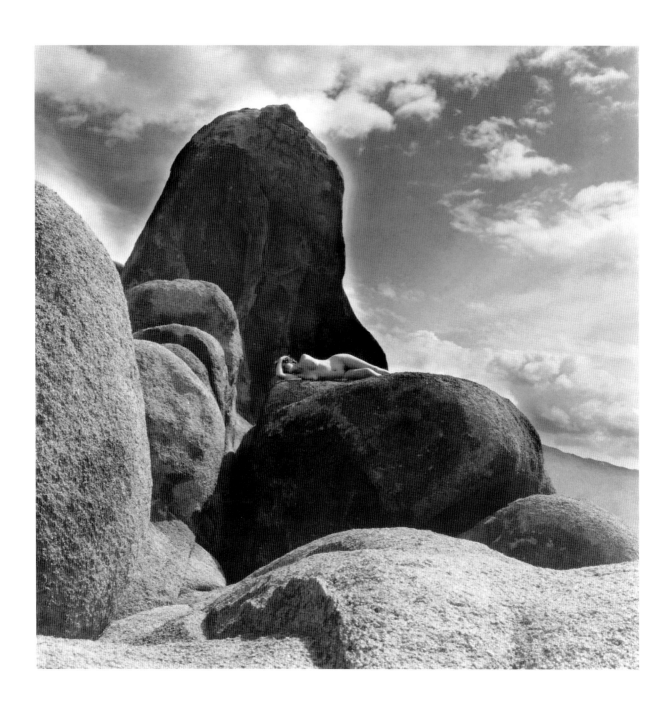

59. Peggy, Alabama Hills, 1991

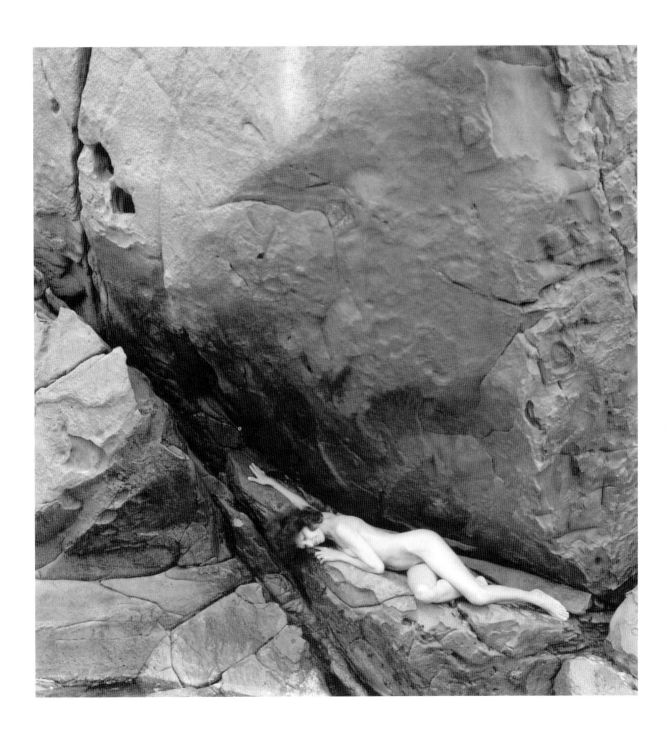

60. Gloria, Garrapata #1, 1990

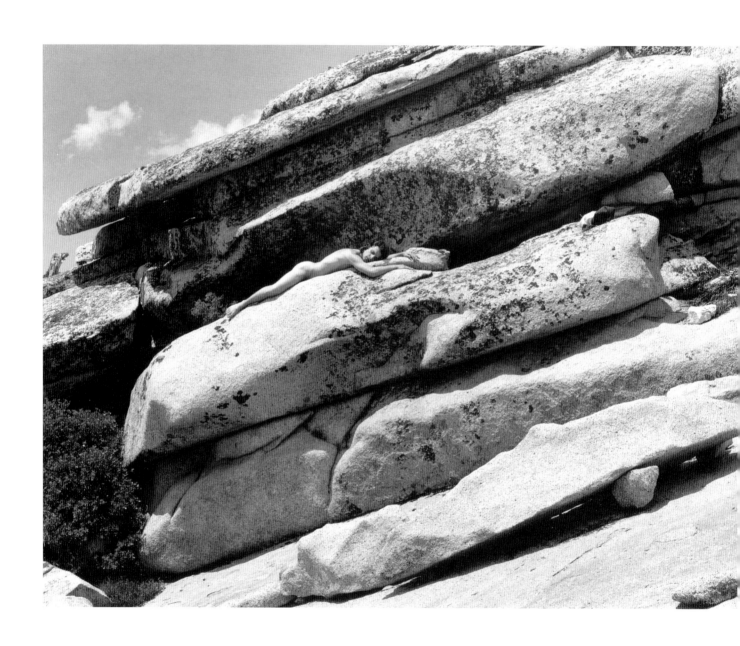

61. Michael at Olmsted Point #2, 1986

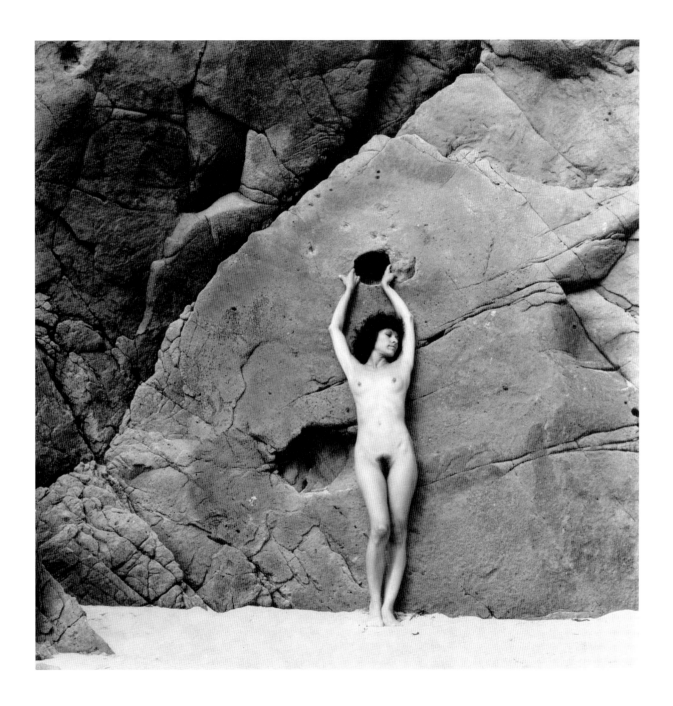

62. Nude and Holes, 1990

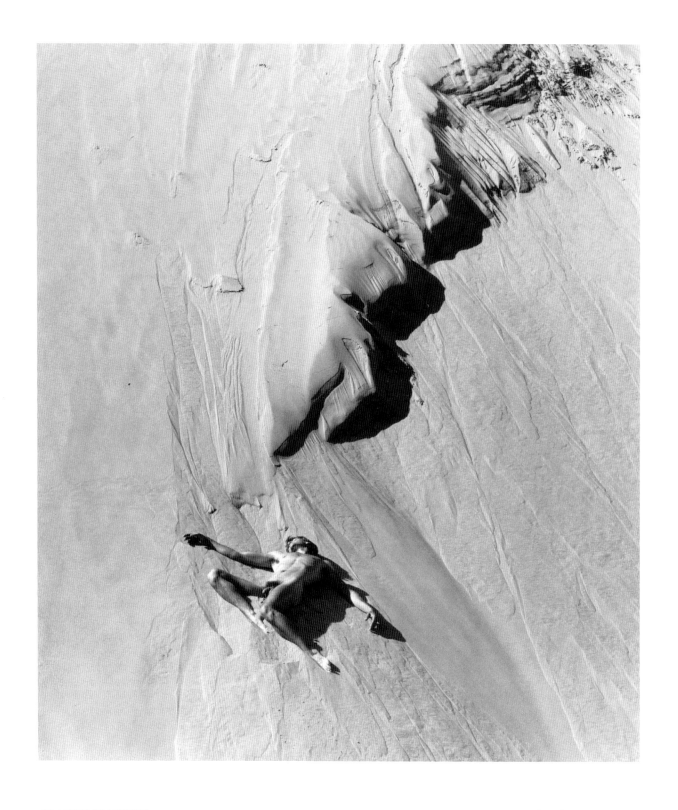

63. David at the Point, 1984

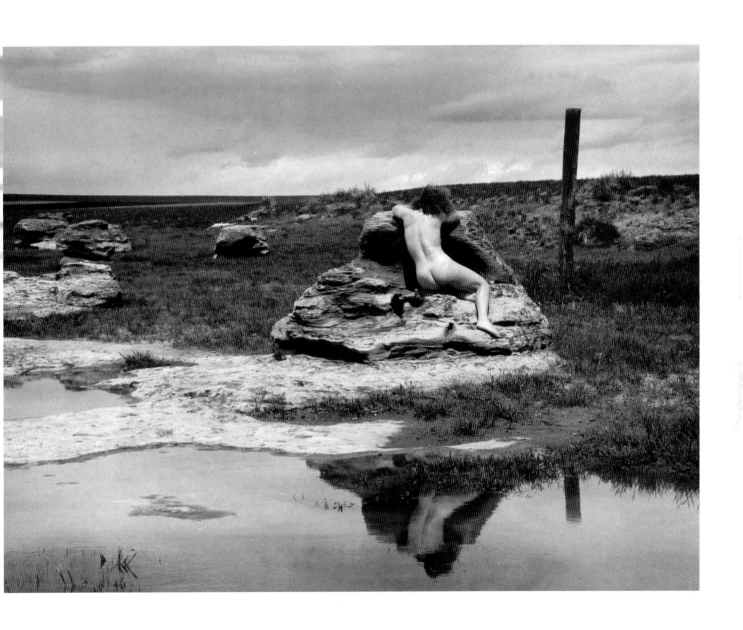

64. Sandy and Reflection, 1986

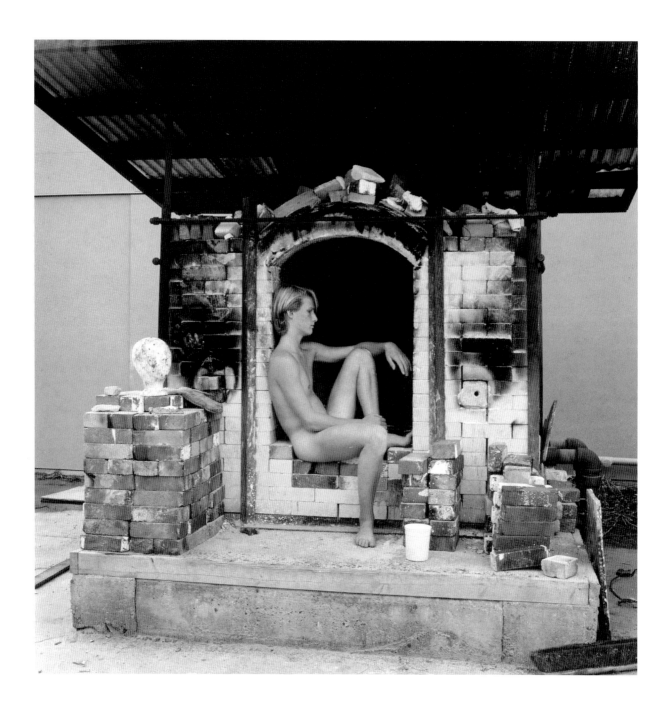

65. Michael and Kiln, 1986

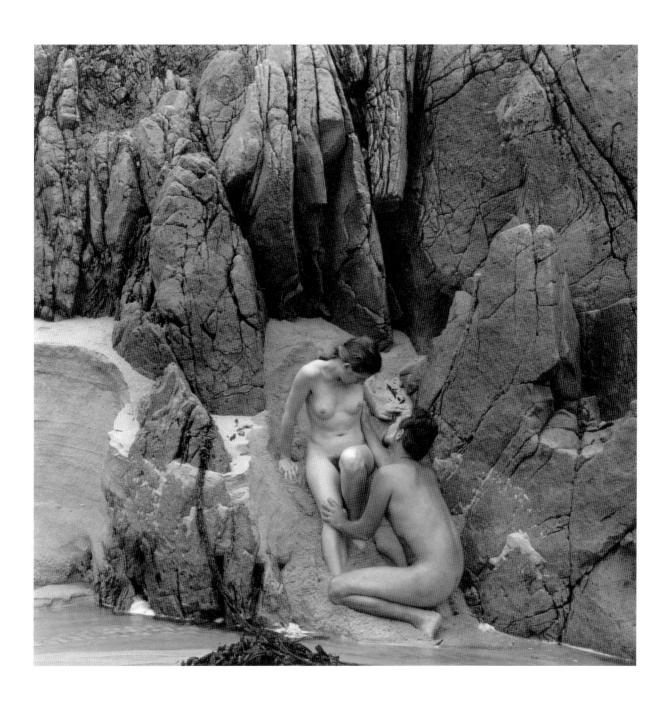

66. Nude Couple at Garrapata Beach, 1987

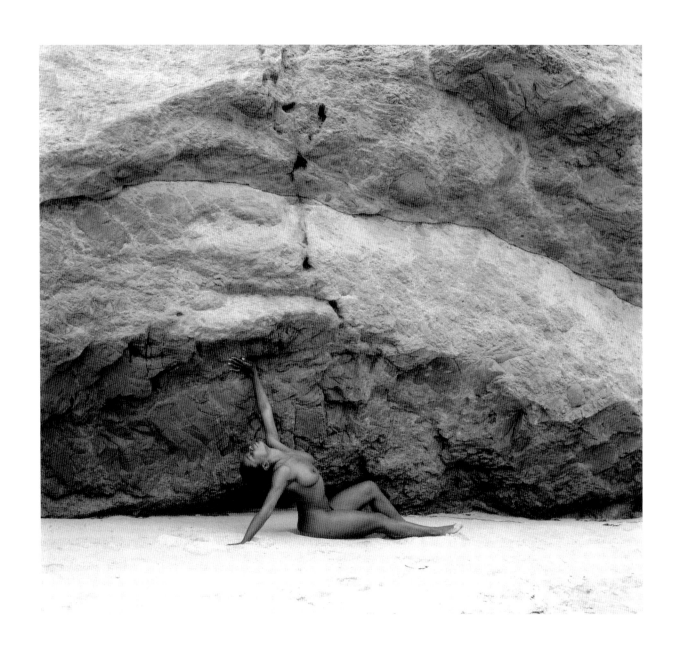

67. Neta #10, 1991

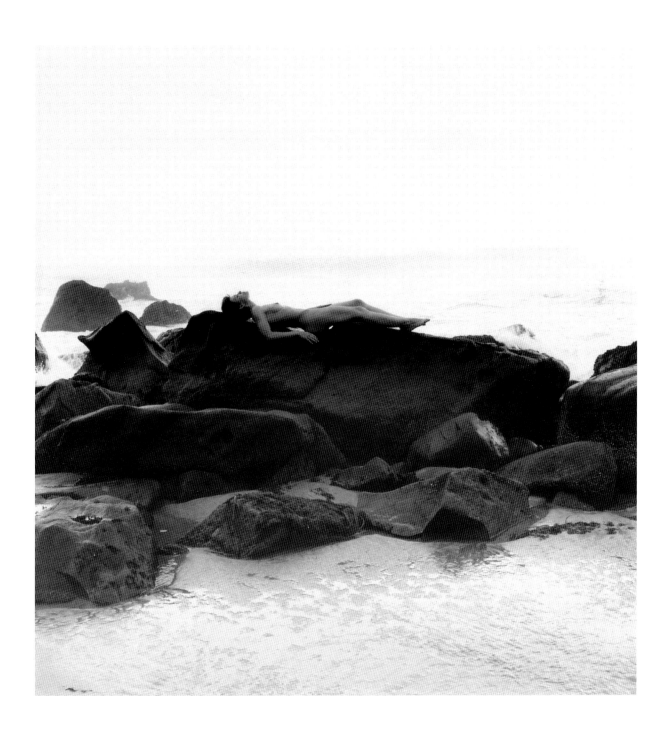

68. Jane on the Rocks, 1988

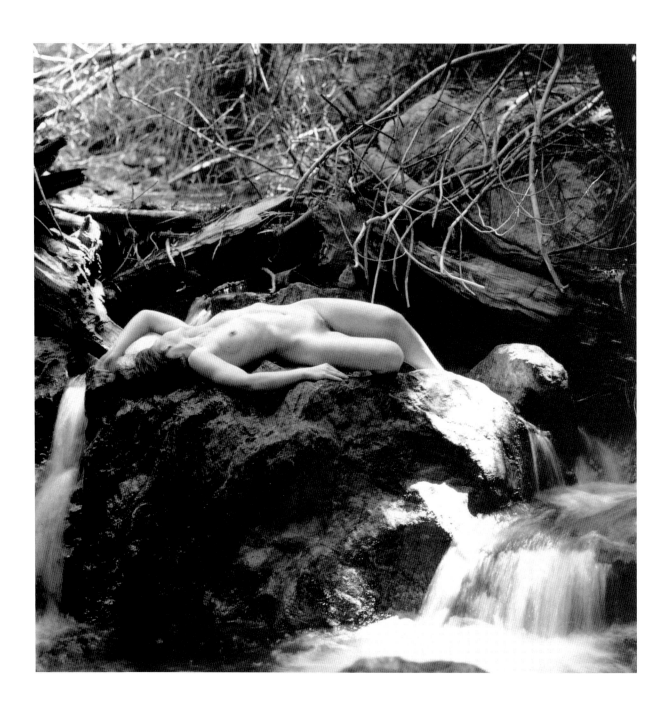

69. Jane, Partington Canyon, 1989

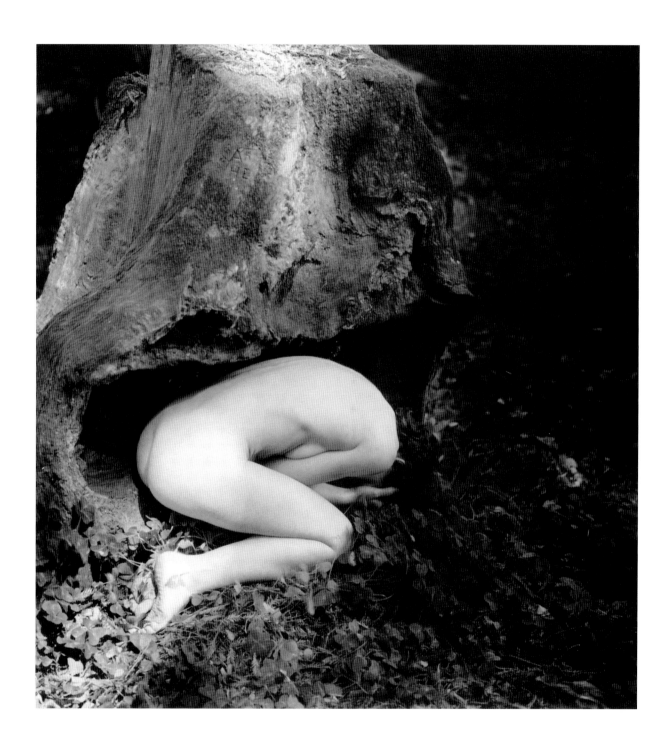

70. Jane in Tree Trunk, 1988

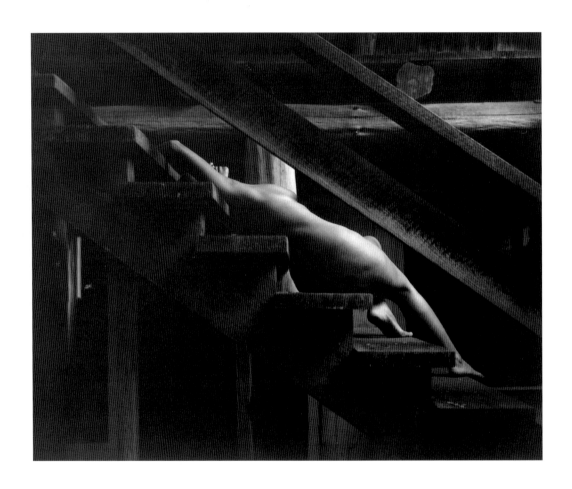

71. Linda on Steps, 1979

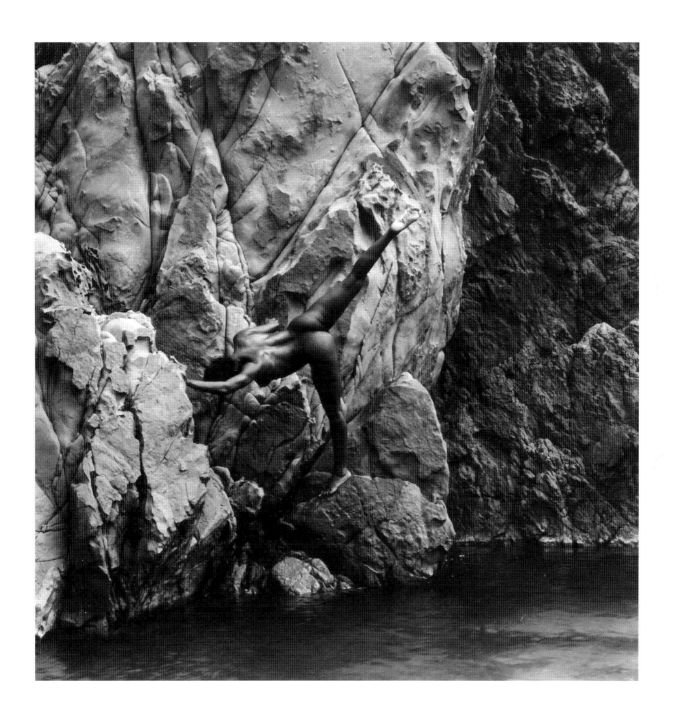

72. Arabesque, 1990

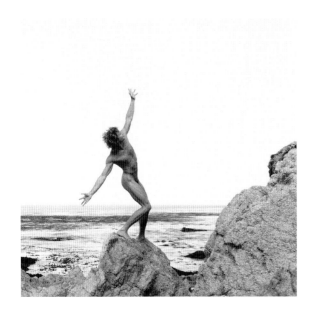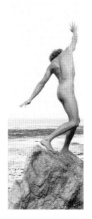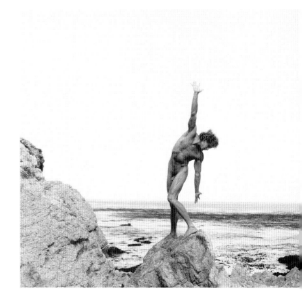

73. Movement on Rocks, 1988

AFTERWORD

I N THE SPIRIT OF THIS INTIMATE book, intended as a warm and personal look at the artist as much as the art, my brief essay focuses on the persona of Edna Bullock as she has revealed herself in her later life through her photographs.

Edna Bullock and I were both married to photographers when we first met in Carmel in 1967, and perhaps we were wed also to the idea of photography as art (though neither of us would have said so at the time). Wynn Bullock and William Current, our spouses, had been friends for some time and Wynn and Edna had been married for 24 years at the time I entered that Carmel circle of photographers. Most photographers were struggling or holding down day jobs to support their habit, for photographic prints remained a relatively cheap commodity. Friends usually brought a print to dinner as a house gift, in lieu of a bottle of wine. An evening's entertainment revolved around viewing new work, or in philosophical and historical discussions about photography. Often with Wynn, the conversation turned to the fourth dimension—time —which he expressively explored in his photographic work. At the end of the evening, artists would often trade a print, a gesture both of mutual respect and acknowledgment of the other's art.

We also breathed the air of that photographic climate of Carmel where, in the late '60s, Brett Weston and Cole and Margaret Weston, Beaumont and

Nancy Newhall, Ansel and Virginia Adams, Morley and Frances Baer and a host of other photographers worked at their art. The Friends of Photography at the Sunset Center in Carmel was then just a nascent idea that was building and Maggie Weston's photographic gallery, now a landmark, wasn't even a gleam in her eye.

Edna and I lived on the edges of the circle, both of us engaged in "real" jobs to help support the artistic endeavors of the men in our lives, but at the same time, we inhabited a living laboratory. Whether we realized it or not, we were as good as enrolled in a college degree program in the history of photography and its practices, all on the eve of the next evolution of photography as an art form.

Edna embarked on her photographic journey in the mid-seventies, following Wynn's death, and her career now spans two decades. Her subject matter, naturally enough, initially emulated her husband's and the Carmel circle, the nude figure among her subjects.

In her choice of the female nude as subject, Edna follows in the tradition of many distinguished photographers, men and women. In his essay, "Nude in a Social Landscape," Ben Maddow noted:

"Of the nearly five hundred photographs reproduced in *Camera Work*, by marvelous gravure on heavy Japanese paper, four were male, and some thirty were female nudes; a number of these were done by women."

Photographs of male nudes, however, were less common. In *The Male Nude in Contemporary Photography,* Melody Davis comments, "In photography as in painting from the nineteenth century onward…[the male nude] registers more as an absence than as a presence." Imogen Cunningham's allegorical images of her nude husband in outdoor settings caused a scandal when she showed them in 1917. While many female photographers photographed their male progeny as young boys, the male nude as subject remained discreetly out of view and of critical focus.

In 1978 the Marcuse Pfeifer Gallery produced a landmark exhibition entitled, *The Male Nude: a Survey in Photography*, which included the work of 78 photographers nearly a third of them female. In the catalog, Shelley Rice noted the "work represents the mere tip of a long-submerged iceberg that needs to be comprehensively explored." Even so, two critics—both male—strongly objected on the grounds that any photograph of an unclothed male body presents a sex object. Critic Vicki Goldberg responded, "Women's frank appreciation, however, might be rearranging matters; it would be splendid, and ironic, if women were the ones to restore men's sense of the beauty and dignity of their bodies."

The male nude in photography is still not an altogether comfortable subject. In the Metropolitan Museum's 1994 Eakins exhibition, which includes his photographs of nude males, the captions suggest that the pictures were shocking then, but they may be just as shocking to contemporary audiences.

I suspect Edna Bullock, celebrating her 80th birthday with the publication of this book, is unconcerned. She has pursued her photographic vision in the same direct and unequivocal manner that has characterized

her former life pursuits, which include teaching; a 40-year partnership with a well-known photographer; motherhood; widowhood; and a new career.

A long-time teacher, Edna became an unsurpassed student at age 60. She moved from workshop student to workshop instructor because of her intense dedication and desire.

Edna's images initially reflected the familiar things that inscribed her many-decade Monterey existence. (While not the subject of this book, Edna Bullock photographs by the hundreds exist of the Monterey-Carmel landscape and its details). Her camera began to accompany her on traditional visits to swap meets and flea markets, and familial visits to her beloved daughters. On the East Coast Edna found nude figures gracing barn doors as she prowled the environs near her daughter Barbara's Massachusetts home. In the West, she created the photographic moment reflecting both relational subjectivity and resonance with universal themes. Her daughter Lynne nurses her child, both figures nude. Edna renders a sense of private intimacy, neither lavish nor dramatic; of motherhood in unembellished terms.

Edna Bullock clearly began to move more freely in her work. Her years of experience teaching dance and physical education inform the models' movements and relationship to the natural setting. The element of dance is even more striking as her models respond to interior spaces, where the focus on the body becomes more intense. Perhaps Edna's male nudes are so compelling because of the implicit relationship to her subject. One senses her sympathy yet her distance. For me the most powerful photographs are her darker images of nude males, where isolation, loneliness, despair, and loss are the subjects. The photograph of Jeff with his beautiful, muscular ebony body standing in stark contrast to a thin, fragile old man seated on the ground, his hand delicately touching the aged, white flesh offers layers of meanings and longings. The contrasts are obvious—youth and age, strength and weakness, power and submission, black and white—yet the messages are subtle.

Edna also has a good sense of humor: witness her tongue-in-cheek attitude and irreverent referencing of "classic" images. The nude model in the car going nowhere hints of a well-known Weston photograph; the model, posed among many-handed knotholes, is a humorous twist on a favorite "Wynn" subject. There are also mythic references and erotic suggestion.

During the course of choosing the work for exhibition and later in deciding the order in which her images would appear in publication, Edna sat at a little distance taking in the process. At times she showed mild surprise, at others some amusement, and once in a while a furrowed brow, but she said very little. She neither explained, nor defended, expanded upon nor took umbrage at the response to her images. Her photographs are inextricably bound to and expressive of the varied fabric of her life, and the very act of the making has been sufficient. The rest is the soufflé.

—Karen Current Sinsheimer
Curator of Photography
Santa Barbara Museum of Art

VITA

BRIEF PERSONAL HISTORY

Born Edna Jeanette Earle, May 20, 1915, in Hollister, California.

Baby picture, circa 1915.

8th-grade graduation

Modesto Junior College, circa 1936

who was ill with cancer. A year after Wynn's death in 1975, enrolled in beginning photography class at local community college and began own photographic career at age 61.

Attended local public elementary and secondary schools. Received A.A. from Modesto Junior College, 1936; B.E. in Physical Education from University of California at Los Angeles, 1938; and Certificate of Completion for General Secondary Teaching Credential from University of California at Berkeley, 1940. Taught physical education and dance at Fresno High School, 1940-43. Married photographer Wynn (Percy Wingfield) Bullock in 1943; step-daughter, Mary Wynne (Mimi) (b. 1930); daughters Barbara Ann (b. 1945) and Lynne Marie (b. 1953). Settled in Monterey, California, 1946. Full-time mother, homemaker, and helpmate until late 1950's when teaching career was resumed, first as substitute, then as full-time teacher. Taught physical education, dance, and then home economics at high school and junior high levels. Retired in 1974 to care for Wynn

PHOTOGRAPHIC EDUCATION

Archival processing, mounting, and 32 years of life experiences with Wynn Bullock.
Monterey Peninsula College with Henry Gilpin, Ron James, Tom Millea, and David Fuess.
Workshops with Ansel Adams, Morley Baer, Judy Dater, Eikoh Hosoe, Eva Rubenstein, Jerry Uelsmann, Al Weber, and others.

LECTURER, TEACHER, AND WORKSHOP LEADER

Ansel Adams Gallery Workshops (teaching assistant), Yosemite, California.
Cabrillo College, Aptos, California.
California State University, Chico, California.
Carmel Coast Photography Workshops, Monterey, California.
Carmel High School, Carmel, California.
Center for Photographic Art, Carmel, California.
Creative Expression Workshops for Women, Salinas, California.
DeAnza College, Cupertino, California.
Fresno Metropolitan Museum, Fresno, California.
Friends of Photography, Carmel and San Francisco, California.
Grupo Fotografico Imagenes, Mexicali, Baja California.
Monterey Peninsula College, Monterey, California.
Monterey Peninsula Photographic Workshops, Monterey, California.
Mt. Pleasant High School, San Jose, California.
New Mexico Photography Workshops, Santa Fe, New Mexico.
North Orange County Community College, Fullerton, California.
Oliver Gagliani Workshops, Virginia City, Nevada.
Palm Beach Photography Workshops, Boca Raton, Florida.
Palomar College, San Marcos, California.
Photographic Center of the Monterey Peninsula, Carmel, California.
Photographic Institute of Billings, Billings, Montana.
Photographic Vision Workshops, Carmel, California.
Professional Photographers of Southern California, Los Angeles, California.
Royal Photographic Society, Pacific Chapter, San Francisco, California.
San Jose City College, San Jose, California.

Dance pose by Wynn Bullock, 1961

Santa Catalina School for Girls, Monterey, California.
Santa Fe Center for Photography, Santa Fe, New Mexico.
Steve Anchell's Photographic Workshops, Los Angeles, California.
University of California, Riverside, California.
University of California, ASUC Arts Studio, Berkeley, California.
University of California Extension, Santa Barbara, California.
University of California Extension, Santa Cruz, California.
University of Oregon, Eugene, Oregon.

Above Little Sur River by Ruth Jackson, 1980s

SELECTED SERVICE ACTIVITIES

Friends of the Arts, University of California at Santa Cruz. Member of Board of Directors from inception in 1983 through 1987.
The Photographic Center of the Monterey Peninsula, Carmel, California. Founding member and director from 1988 to 1991.
Center for Photographic Art, Carmel, California. Member of Board of Trustees from 1991 through 1993. Elected Honorary Trustee in 1994.

Edna and Wynn Bullock by Jim Hill, 1974

BOOKS BY

Edna's Nudes—Photographs by Edna Bullock, text written and edited by Barbara Bullock-Wilson with Afterword by Karen Sinsheimer, Capra Press, Santa Barbara, California, 1995.

Edna by Will Wallace, her mailman, mid-1980s

SELECTED BOOKS AND ARTICLES ABOUT

Photographers' Encyclopaedia International, Editions Camera Obscura, Switzerland, 1985 (CD-ROM ed., 1995).

"Edna Bullock," by Patricia Gardner in *The Creative Woman,* Vol. 9, No. 4, Governors State University, University Park, Illinois, Summer 1989.

"A Gathering of Friends—An Interview with Edna Bullock," by Donna Conrad in *Camera & Darkroom,* Los Angeles, California, February 1993.

"Faces and Figures—The Photographs of Wynn and Edna Bullock," in *Fotofeis: Scottish International Festival of*

Photography, exhibition catalogue, Edinburgh, Scotland, 1993.

"A Nude Awakening," by Ruth Wishart in *The Scotsman,* Edinburgh, Scotland, June 5, 1993.

"Through a Lens Magically," by Richard Pitnick, *Coast Weekly,* Carmel, California, August 19, 1993.

"A Conversation with Edna Bullock and Barbara Bullock-Wilson," by Brooks Jensen in *LensWork Quarterly,* Portland, Oregon, Fall 1994.

Contemporary Photographers, 3rd ed., Gale Research International, Detroit, Michigan, 1995

PHOTOGRAPHS IN SELECTED PUBLICATIONS

Happy, Happy, Happy, by Lois Earle, Lane Printing & Publishing Co., Mesa, Arizona, 1977.

Photo-image, Vol. 1, No. 3, Lodestar Press, Inc., 1977.

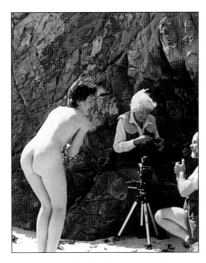

Jane Murray and Edna by Dan Carroll, 1988

Cows, Poets, & Other Loves, by Caryl Hill and Deborah Weston, Three Furies Press, Carmel, California, 1978.

Cutbank 16, Special Western Edition, Associated Students of University of Montana, Billings, Montana, 1980.

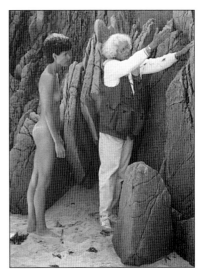

Gloria Navarro and Edna by Richard Gadd, 1988

A Taste of Honey, by Lois Earle, Arizona Specialty Printing, Mesa, Arizona, 1981.

Combing the Coast I, by Ruth A. Jackson, Chronicle Books, San Francisco, California, 1981.

Combing the Coast II, by Ruth A. Jackson, Chronicle Books, San Francisco, California, 1982.

Cutbank 18, Associated Students of University of Montana, Billings, Montana, 1982.

Monterey Life, Alacron Communication Group, Monterey, California, 1982.

Best of Photography Annual, Photographer's Forum Magazine, Chicago, Illinois,1985.

Combing the Coast, Highway One from San Francisco to San Luis Obispo, by Ruth A. Jackson, Chronicle Books, San Francisco, California, 1985.

En Marcha—Spanish Reading Series, Macmillan Publishing Co., New York, New York, 1985.

Naked: A Portfolio, University of Colorado, Boulder, Colorado, 1986.

Community Focus, Community Foundation for Monterey County, Monterey, California, 1987.

The Naked and the Nude: A History of Nude Photography, by Jorge Lewinski, Weidenfeld & Nicholson, London, England, 1987.

ZYZZYVA, Vol. III, No. 1, Zyzzyvz, Inc., San Francisco, California, 1987.

Erotic by Nature, edited by David Steinburg, Shakti Press, North San Juan, California, 1988.

Utne Reader, No. 29, September/October, Lens Publishing Co., Minneapolis, Minnesota, 1988.

California Art Review, Second and Third Editions, by Les Krantz, American Reference, Inc., Chicago, Illinois, 1989.

Open Studio Tours Catalog, Artists' Equity Association, Central Coast Chapter, Pacific Grove, California, 1989.

Zoom—The International Image Magazine, October/November, ZAO, Paris, France, 1989.

Edna in Russia, 1992

Open Studio Tours Catalog, Artists' Equity Association, Central Coast Chapter, Pacific Grove, California, 1991.

Open Studio Tours Catalog, Artists' Equity Association, Central Coast Chapter, Pacific Grove, California, 1992.

Haddad's Fine Arts 7th Edition Catalog, Haddad's Fine Arts, Inc., Anaheim, California, 1994.

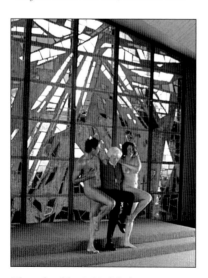

Edna and models at UC Berkeley by M.N. Ott, 1991

Edna with styrofoam model by Gordon Brown, 1993

INDIVIDUAL EXHIBITIONS

1977
Country Club Camera Store, Pacific Grove, California.
Shado Gallery, Portland, Oregon.

1979
Governors State University, University Park, Illinois.
Pacific Grove Art Center, Pacific Grove, California.
Photo-Synthesis Gallery, Clovis, California.

1980
Cafe Balthazar Gallery, Pacific Grove, California.
Collectors Gallery, Pacific Grove, California (with Wynn Bullock).

1981
Focus Gallery, San Francisco, California (with Wynn Bullock).
San Jose City College, San Jose, California (with Wynn Bullock).

1982
Exposures Gallery, Libertyville,
Illinois (with Wynn Bullock).
Jeb Gallery, Providence, Rhode
Island (with Wynn Bullock).

1983
Ledel Gallery, New York, New York
(with Wynn Bullock).
Neikrug Gallery, New York, New
York (with Wynn Bullock).
Santa Fe Center for Photography,
Santa Fe, New Mexico (with
Wynn Bullock).

1985
Cape Cod Museum of Natural
History, Brewster, Massachusetts.
Spectrum Gallery, Fresno,
California (with Martha Duff).
Vision Gallery, San Francisco,
California (with Wynn Bullock).

1986
Photography at Oregon Gallery,
Eugene, Oregon (with Wynn
Bullock).
University of Santa Clara, Santa
Clara, California.
Yellowstone Art Center, Billings,
Montana (with Wynn Bullock).

1987
Betty Garland Gallery, San
Francisco, California (with
Morrie Camhi and Martha
Casanave).
Exposure Gallery, Orleans,
Massachusetts.
Olive Hyde Art Gallery, Fremont,
California (with Wynn Bullock).

1989
Axis/291, Richmond, Virginia.
Michigan State University, East
Lansing, Michigan.
Pacific Grove Art Center, Pacific
Grove, California.

Edna at Big Sur by Randall Lamb, 1987

1990
Foto Galerie, Chincoteague,
Virginia (with Wynn Bullock).
South Suburban College, South
Holland, Illinois.

1991
Carl Cherry Foundation, Carmel,
California (with sculptor Ken
Wiese).
Monterey Peninsula Unitarian
Church, Carmel, California.
California State University, Chico,
California (with Ruth Bernhard).

1993
G. Ray Hawkins Gallery, Santa
Monica, California (with Wynn
Bullock).
Halsted Gallery, Birmingham,
Michigan (with Wynn Bullock).
Photo Forum, Pittsburgh,
Pennsylvania (with Wynn
Bullock).
PhotoZone Gallery, Eugene,
Oregon (with Wynn Bullock).
University of Edinburgh,

Edinburgh, Scotland (with
Wynn Bullock) (part of Fotofeis,
the Scottish International
Festival of Photography).

1995
Edna's Nudes, a traveling exhibi-
tion first sponsored by Center
for Photographic Art and Thun-
derbird Bookshop at Marjorie
Evans Gallery, Carmel, Califor-
nia (May 1995). Other venues
include: F Stops Here Gallery,
Santa Barbara, California (June–
July 1995); Halsted Gallery,
Birmingham, Michigan (October
1995); S. K. Josefsberg Studio,
Portland, Oregon (December
1995); museum of Palm Beach
Center for Photography, Del Rey
Beach, Florida (January–Febru-
ary 1996); Sarah Spurgeon
Gallery, Central Washington
University, Ellensburg, Washing-
ton (October 1996).

GROUP EXHIBITIONS

1977
Portrait of the Earth, Southwest
Center of Photography, Austin,
Texas.
Women, Southwest Center of
Photography, Austin, Texas.

1978
Fifty Outstanding Photographers,
Silver Image Gallery, Seattle,
Washington.
Friends of the Door, The Print
Gallery, Carmel, California.
*Twenty Western Photographic
Artists*, Reflections Gallery of
Photography, Sedona, Arizona.

1980
December 1980 Regional Exhibition,

Eclipse Gallery,
Boulder, Colorado.

1981
*Master Photographers of the 20th
Century*, Edwynn Hauk Gallery,
Chicago, Illinois.
Members' Exhibition,
Cameravision, Los Angeles,
California.
*Twenty-ninth Photography
Invitational*, Monterey Peninsula
Museum of Art, Monterey,
California.
Western Images, William K. Lyons
Gallery, Coral Gables, Florida.
Women Photographers, Palo Alto
Cultural Center, Palo Alto,
California.

1982
Art in the Redwoods, Town of
Gualala, California.
Members' Exhibition,
Cameravision, Los Angeles,
California.
Opening Exhibitions, The
Photographer's Gallery, Palo
Alto, California.
*Photography from Victor School
Faculty*, Governors State
University, University Park,
Illinois.

1983
*California Mystique: Contemporary
Women Artists*, California
Polytechnic State University, San
Luis Obispo, California.
*Juried Landscape Photography
Show*, Pacific Grove Art Center,
Pacific Grove, California.
Members' Exhibition, Santa Fe
Center for Photography, Santa
Fe, New Mexico.
*Photographs from the Collection of
Jane Reese Williams:
Photographs by Female*

Edna at a Big Sur Workshop by Evie Sullivan, 1990

Photographers, Santa Fe Center
for Photography, Santa Fe, New
Mexico.
*Point Lobos—The 50th
Anniversary in Photographs*,
Photography West Gallery,
Carmel, California.

1984
Men by Women, An American
Place, Flossmoor, Illinois.
Point Lobos: Place as Icon, Friends
of Photography, Carmel,
California.
*Second Northern California Juried
Photographic Exhibition*,
Monterey Peninsula Museum of
Art, Monterey, California.
The Nude—Classic Beauty, Silver
Image Gallery, Seattle,
Washington.
The Unseen Photographs, The
Photography Gallery, La Jolla,

California.
U.S. Biennial II, University of
Oklahoma, Norman, Oklahoma.
Vision of America at Peace,
Trade Center, San Francisco,
California.

1985
A Women's Show, The
Photographer's Gallery, Palo
Alto, California.
Members' Exhibition, Los Angeles
Center for Photographic Studies,
Los Angeles, California.
Naked, University of Colorado,
Boulder, Colorado.
*Second Annual Photography
Contest*, Monterey Peninsula
College, Monterey, California,
(1st Place in Black and White).
The Nude Show, Photographic
Image Gallery, Portland, Oregon.
Third Northern California Juried

Photographic Exhibition, Monterey Peninsula Museum of Art, Monterey, California.

Two's Company, The Photographer's Gallery, Palo Alto, California.

1986

California Insurance Group Photographic Competition, Monterey, California (President's Award).

Commitment to Vision, University of Oregon, Eugene, Oregon (traveled to twelve other U.S. cities).

Fourth Annual Photo Competition, Monterey Peninsula Museum of Art, Monterey, California.

The Nude, The American Art Company, Tacoma, Washington.

1987

Community Visions, sponsored by the Community Foundation for Monterey County, Monterey, California.

Photographs Representing the MPC Photography Workshops, Pacific Grove Art Center, Pacific Grove, California.

1988

Behold the Man, Stills Gallery, Edinburgh, Scotland.

Dunescapes, The Photographic Center of the Monterey Peninsula, Carmel, California.

Members' Exhibition, The Photographic Center of the Monterey Peninsula, Carmel, California.

The Human Vessel, Museum of Photography, Antwerp, Belgium.

1989

Abstract Exhibit, The Photographic Center of the Monterey Peninsula, Carmel, California.

Artists' Equity Studio '89, Pacific Grove Art Center, Pacific Grove, California.

Community Visions, Monterey Peninsula Airport, Monterey, California.

Erotic by Nature, Dancing Man Gallery, Santa Cruz, California.

F:48 - 48 Hours on the Monterey Peninsula, The Photographic Center of the Monterey Peninsula, Carmel, California.

Figures and Faces '89, Josephus Daniels Gallery, Carmel, California.

Women in Photography International, Pacific Grove Art Center, Pacific Grove, California (traveled to Seattle, Washington; Bath, England; Portland, Maine; Stockholm, Sweden; Sicily, Italy).

The New American Landscape, 1989 Biennial Juried Exhibition, Pacific Grove Art Center, Pacific Grove, California (cash award).

1990

A Celebration—150 Years of Photography, David Adler Cultural Center, Libertyville, Illinois.

Educational Steps, Santa Fe Center for Photography, Santa Fe, New Mexico.

Flashback: A Photographic Reflection of Monterey, Monterey Conference Center, Monterey, California.

Photo Lore, Hartnell College Gallery, Salinas, California (traveled to Del Mar, California; Professional Photographers' of America Conference, Anaheim, California).

1991

Artists' Equity Studio '91, Pacific Grove Art Center, Pacific Grove, California.

International Exhibit of Women Photographers, sponsored by the Union of Photographers of the U.S.S.R. (opened in Ryazan and traveled throughout the Soviet Union).

Lobos—A Tribute to Point Lobos, Carl Cherry Foundation, Carmel, California.

To Collect the Art of Women—The Jane Reese Williams Collection of Photography, Museum of New Mexico, Santa Fe, New Mexico.

1992

Artists' Equity Studio '92, Pacific Grove Art Center, Pacific Grove, California.

Group Exhibition, Imagery Gallery, Lancaster, Ohio.

Land of Mary Austin, Carl Cherry Foundation, Carmel, California.

The Nude, Grant Gallery, Denver, Colorado.

The Nude—Classic Beauty, Silver Image Gallery, Seattle, Washington.

1993

Figures, Portraits, Persona— Photographic Works by Female Artists, Clarion University, Clarion, Pennsylvania.

Group Exhibition, Photographic Image Gallery, Portland, Oregon.

1994

Dreaming Art—Visual Aids, Carl Cherry Center for the Arts, Carmel, California.

The Male Nude, Scott Nichols Gallery, San Francisco, California.

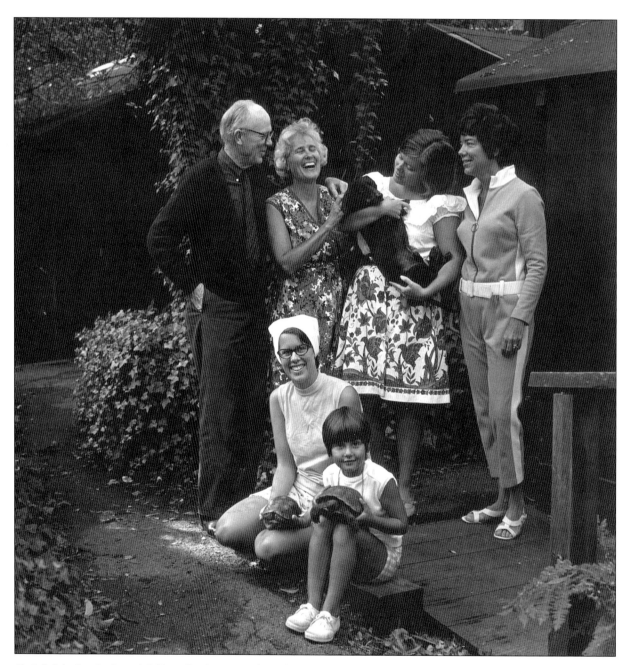

The Bullock family at Ben Lomond, California (Standing: Wynn, Edna, Barbara with Hapi and Mimi; Seated: Lynne, Elizabeth — Mimi's daughter — and the family's desert tortoises) by Todd Walker, mid-1960s

LIST OF PLATES

40. *Untitled*, 1984
(10$^1/_2$ x 13$^5/_8$)

41. *Nude and Pillar*, 1993
(8$^1/_2$ x 10$^7/_8$)

42. *Arm*, 1991
(12 x 7$^1/_4$)

43. *Karen*, 1989
(10$^1/_2$ x 12$^1/_2$)

44. *Michael*, 1987
(11$^1/_2$ x 10$^1/_2$)

45. *Nude on Bench*, 1993
(10$^1/_8$ x 5$^1/_2$)

46. *Chair's Shadow*, 1989
(10$^1/_4$ x 10$^3/_8$)

47. *Don #12*, 1984
(7$^5/_8$ x 9$^5/_8$)

48. *Heather Resting*, 1989
(7$^5/_8$ x 9$^3/_4$)

49. *Michaelle with Scarf*, 1986
(7$^5/_8$ x 9$^3/_4$)

50. *Nude Couple*, 1986
(10$^5/_8$ x 11)

51. *Neta and Inge*, 1990
(10$^1/_2$ x 10$^3/_4$)

52. *Movement #7*, 1984
(10$^5/_8$ x 13$^5/_8$)

53. *Jeff #9*, 1984
(10$^1/_2$ x 13$^5/_8$)

54. *Michael*, 1986
(10$^5/_8$ x 10$^7/_8$)

55. *Stuart #4*, 1992
(10$^1/_2$ x 10$^3/_4$)

56. *Don and Jeff #5*, 1984
(10$^1/_2$ x 13$^3/_8$)

57. *Neta, Garrapata #2*, 1990
(10$^1/_2$ x 10$^3/_4$)

58. *Nude and Driftwood*, 1991
(10$^3/_8$ x 10$^3/_8$)

59. *Peggy, Alabama Hills*, 1991
(10$^1/_2$ x 10$^1/_2$)

60. *Gloria, Garrapata #1*, 1990
(10$^3/_8$ x 10$^3/_4$)

61. *Michael at Olmsted Point #2*, 1986
(13$^1/_2$ x 10$^5/_8$)

62. *Nude and Holes*, 1990
(10$^5/_8$ x 10$^5/_8$)

63. *David at the Point*, 1984
(10$^1/_4$ x 11$^7/_8$)

64. *Sandy and Reflection*, 1986
(13$^5/_8$ x 10$^1/_2$)

65. *Michael and Kiln*, 1986
(10$^5/_8$ x 10$^7/_8$)

66. *Nude Couple at Garrapata Beach*,
1987, (10$^1/_2$ x 10$^1/_2$)

67. *Neta #10*, 1991
(11$^1/_2$ x 10$^1/_2$)

68. *Jane on the Rocks*, 1988
(10$^3/_8$ x 10$^3/_4$)

69. *Jane, Partington Canyon*, 1989
(10$^5/_8$ x 10$^5/_8$)

70. *Jane in Tree Trunk*, 1988
(10$^1/_2$ x 11$^1/_8$)

71. *Linda on Steps*, 1979
(9 x 7$^1/_2$)

72. *Arabesque*, 1990
(10$^1/_2$ x 10$^3/_4$)

73. *Movement on Rocks*, 1988
(triptych: 17$^1/_4$ x 6$^7/_8$)